P9-APJ-384

I ♥ DRAWING

fabulous
FIGURES

I ♥ DRAWING
fabulous
FIGURES

jane
davenport

Get Creative 6

Get Creative 6

An imprint of Mixed Media Resources
104 West 27th Street
New York, NY 10001

Senior Editor MICHELLE BREDESON

Art Director IRENE LEDWITH

Design and Layout JANE DAVENPORT

Production J. ARTHUR MEDIA

Vice President TRISHA MALCOLM

Chief Operating Officer CAROLINE KILMER

Creative Director DIANE LAMPHRON

Production Manager DAVID JOINNIDES

President ART JOINNIDES

Chairman JAY STEIN

Copyright © 2018 by Jane Davenport

All rights reserved. No part of this publication may be reproduced or used in any form or by any means—graphic, electronic, or mechanical, including photocopying, recording, or information storage-and-retrieval systems—without permission of the publisher.

The designs in this book are intended for the personal, noncommercial use of the retail purchaser and are under federal copyright laws; they are not to be reproduced in any form for commercial use. Permission is granted to photocopy content for the personal use of the retail purchaser.

Library of Congress Cataloging-in-Publication Data
Names: Davenport, Jane, author.
Title: Fabulous figures / by Jane Davenport.
Description: First edition. | New York : Get Creative 6, 2018. | Series:
 I heart drawing | In series statement, "heart" appears as a heart symbol.
 | Includes index.
Identifiers: LCCN 2017042500 | ISBN 9781942021322 (flexi-cover)
Subjects: LCSH: Figure drawing--Technique. | Human figure in art.
Classification: LCC NC765 .D37 2018 | DDC 741.2--dc23
LC record available at https://lccn.loc.gov/2017042500

Manufactured in China

1 3 5 7 9 10 8 6 4 2
First Edition

CONTENTS

INTRODUCTION

hello!

I love drawing! Fashion illustration is where it all began for me. My mother is a fashion designer, and growing up I collected as many beautiful, highly stylized fashion illustrations as I could find in her magazines.

At school I was one of those "kids who could draw," and, after a lot of work and countless hours "practicing" (playing!), I arrived at fashion college

in Paris (very fancy!) with the beginnings of my own style already firmly in place.

In fashion illustration classes you're usually taught a method of measuring the body proportions in head measurements. I found it quite complicated and, rather than let it get in my way, I continued to draw to my own tune. It wasn't until I started teaching my online workshops that I really started to look closely at my process and realize it was a bit different!

Nothing substitutes for real-life observation, and at the same time as I've been developing my illustrative and artistic style, I have clocked up a lifetime of life drawing, which informs my figure drawing and gives me confidence in creating from memory. (However, it takes a fair bit of confidence to roll up to a life drawing class and draw nude people! So until you get to that stage, you can lean on my years of experience.)

The reason this book is called *Fabulous Figures* is because I take artistic license when I create. And, no, there's absolutely nothing wrong with drawing people the way they really look, but my drawings are a fantasy, processed through the personal lens of my own imagination. Limbs are impossibly long, hair defies gravity, eyes are huge, and so on. But I do try to keep all elements based in reality before I show you how to exaggerate them!

I believe drawing is theater and that, as the artist, you can emphasize and reassemble parts of the world as you want. Creating art that is drawn from

my memory and imagination gives me a little extra buzz of accomplishment. So although I acknowledge reality, I bend the rules, too. The beauty of illustration is that everyone knows it's not real!

It's also all women. Of course, men can be utterly fabulous, too, but my drawing interest lies with my own gender. My sole intention in this book is to help give you the confidence to try drawing female figures, too, and add them to your repertoire.

In my last book, *Drawing and Painting Beautiful Faces,* I concentrated on just one part of the body. In this book we look at the whole shebang from top to toe.

My core desire for my students (and you are one now—welcome to the club!) is to create subtle shifts in realizing your own creative capacity. I believe that feeding our artistic nature makes us happier and better people. And the world really does need a little joy from each one of us!

I have taught thousands and thousands of people to welcome back their childhood love of drawing. To be part of another person's new creative confidence brings me untold joy. So it is with great excitement that I now usher you into my studio to share my contagious passion for drawing.

May you draw and soar!

jane davenport

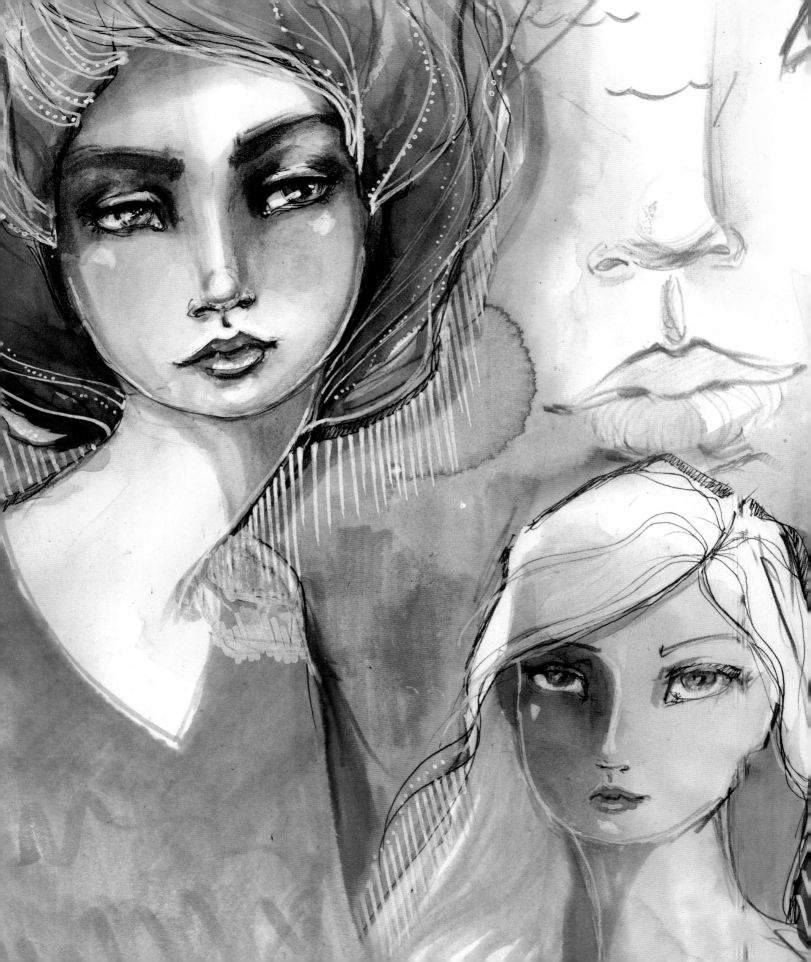

JOYFUL PRACTICE

I just love that the word *artwork* has the biggest clue to improvement built right into it. Work! Reading this book won't be enough to help you improve your drawing. You have to put in the practice.

As I stated earlier, I suggest you keep a journal or sketchbook and put all of your practice from this book in it. Ideally, I would like you to draw along with me throughout every lesson.

Sometimes we resist practicing because we are a little afraid of messing up, making mistakes, or being less than perfect. Well, let me alleviate that fear for you. You WILL mess up, there is no doubt about that. Let me also tell you that without mistakes, and missteps, and mess-ups you are not really learning. So let it happen. Trust the Mess. It means you are making progress.

When you are trying something new, it's very important to accept that you're a beginner and enjoy the process. If you can access the sheer joy of drawing you had as a child, you will want to do more and that joyful practice will lead to a confidence boost and skill building.

Another thought that seems to have a magnetic aura is "I must develop my own style." And although that's true, developing your own style takes practice. Lots and lots and lots of it. Your style can't develop any other way.

The good news is, your style is already inherently there, bubbling away of its own accord. It develops a little more with every drawing you do. Keep learning, keep creating, keep practicing.

Use up your supplies. Create with a smile. Play with color. Draw because you love the feeling of pencil on paper! Appreciate how lucky you are to be a creative being.

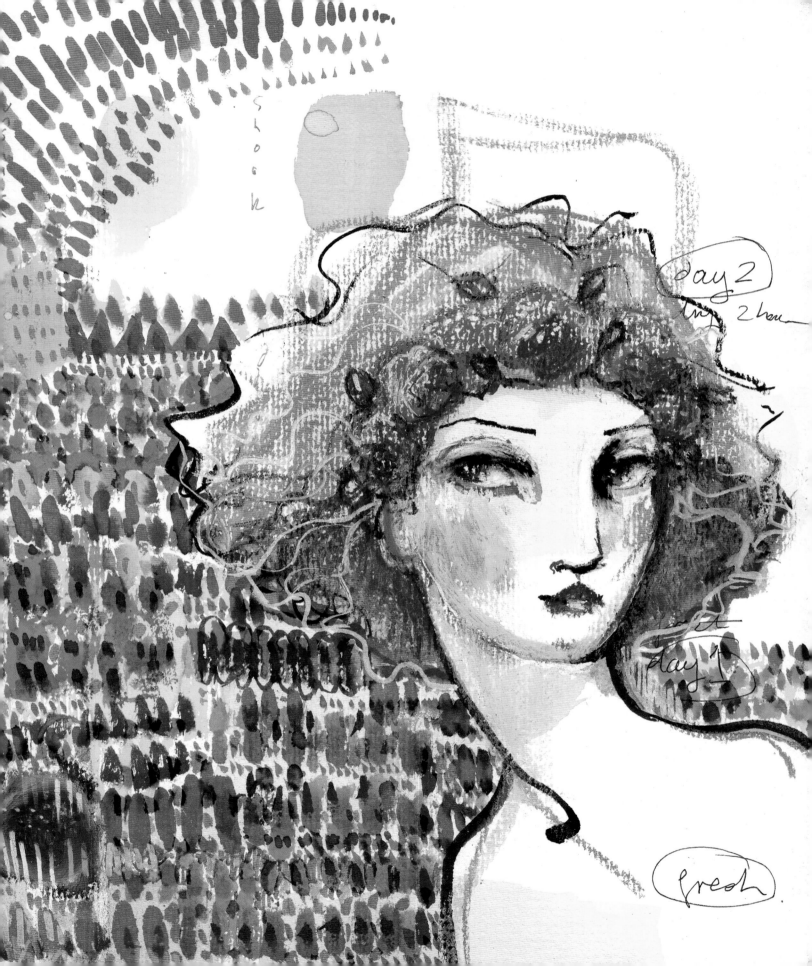

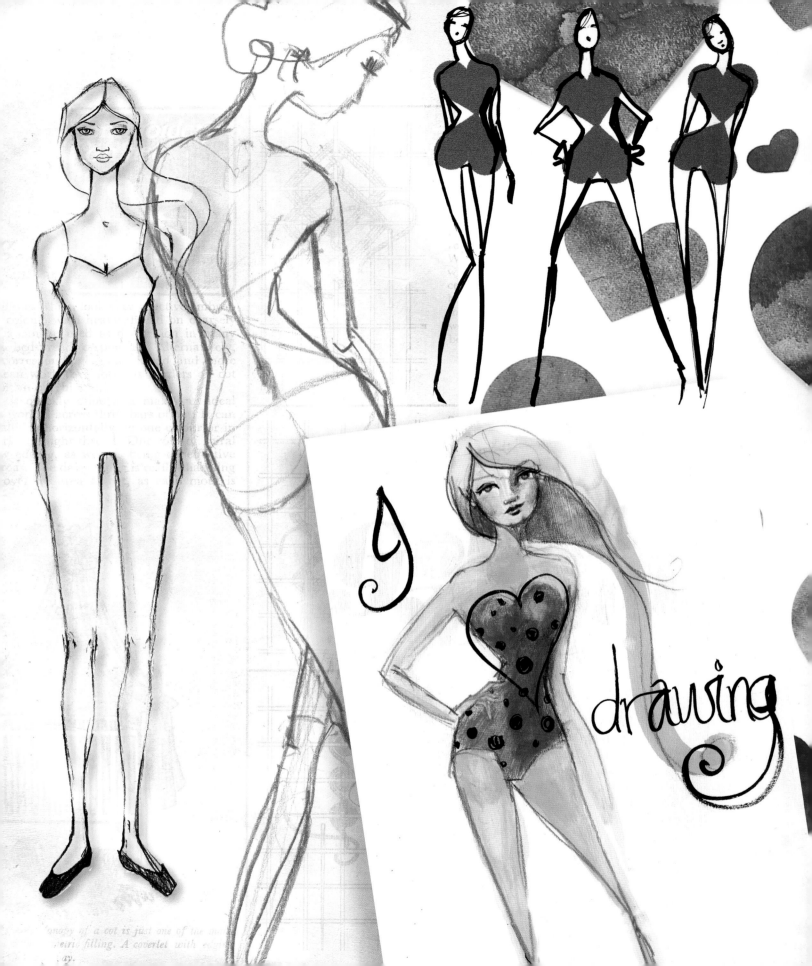

drawing

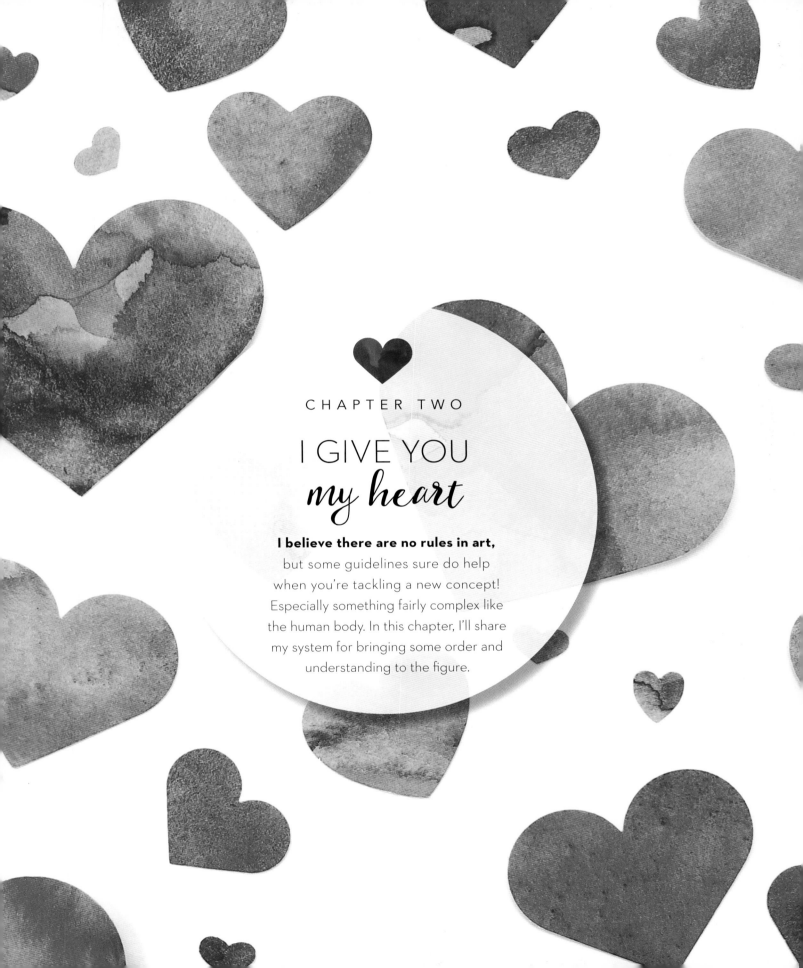

CHAPTER TWO

I GIVE YOU
my heart

I believe there are no rules in art,
but some guidelines sure do help
when you're tackling a new concept!
Especially something fairly complex like
the human body. In this chapter, I'll share
my system for bringing some order and
understanding to the figure.

HEART LINES

When I started teaching online workshops, I wanted to condense all my years of fashion illustration and life drawing sessions with models into a more compact form. I put the way I innately draw figures under the microscope so I could break it down into a helpful, repeatable process.

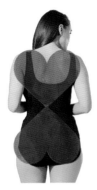

I started from the bottom up! I noticed that there is a distinct, upside-down heart shape at the base of the body. I soon realized that adding the heart's reflection gives it the basic proportions of the torso.

I called this way of forming the upper and lower torso from two symmetrical hearts the **Heart Lines** method.

From the very first time I shared my Heart Lines method, I could see the ease with which it was understood and the wonderful fun and great results my students were having!

Heart Lines are simple, proportional guidelines. We use them to get our key landmarks in, and then reshape around and within them.

Once you have the basic form, you can add the limbs and details and play with your proportions (and we will dive into all these features in later chapters).

Why not copy my little sketch on the right and see how this works in the most basic terms?

Keep things loose and carefree. There's no judgement here!

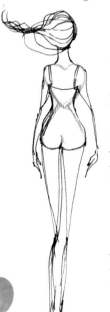

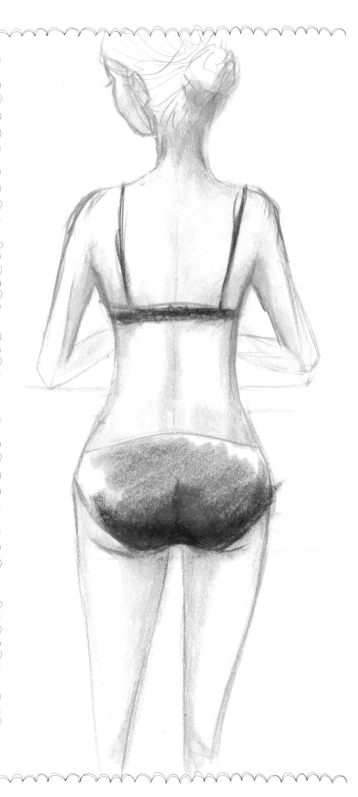

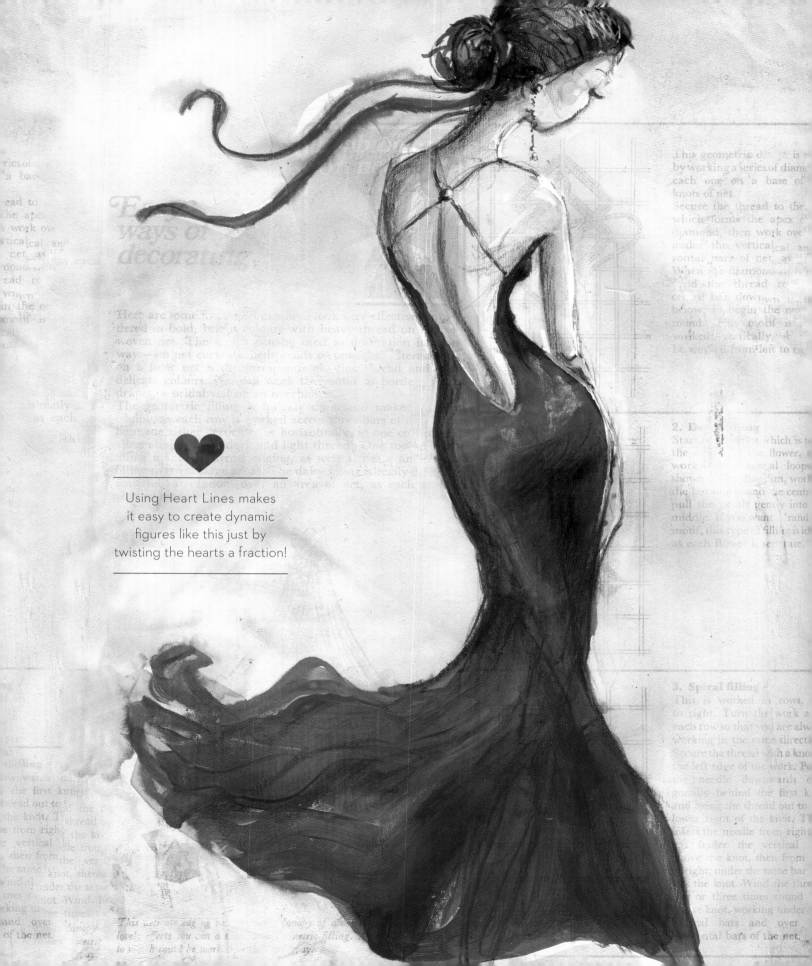

Using Heart Lines makes it easy to create dynamic figures like this just by twisting the hearts a fraction!

Let's turn things around now and apply Heart Lines to the front of the figure. As you can see, the method works just as well!

At the back of the book you'll find a variety of die-cut heart templates. I suggest you punch out the heart templates at the back of this book, flip through a magazine, and place the hearts to see for yourself!

Keep in mind that these are simply proportional guidelines we can use to build the foundations of a female figure.

We can also use hearts to position the top of the bust. Imagine a smaller heart (let's call it the **Minor**) that sits within the top larger heart (let's call it the **Major**).

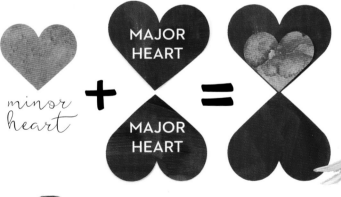

minor heart **+** MAJOR HEART / MAJOR HEART **=**

This Minor Heart can not only help you position and draw cleavage, but it can also help you get the proportion of the head right! This is because it just happens to be about the same height as the head.

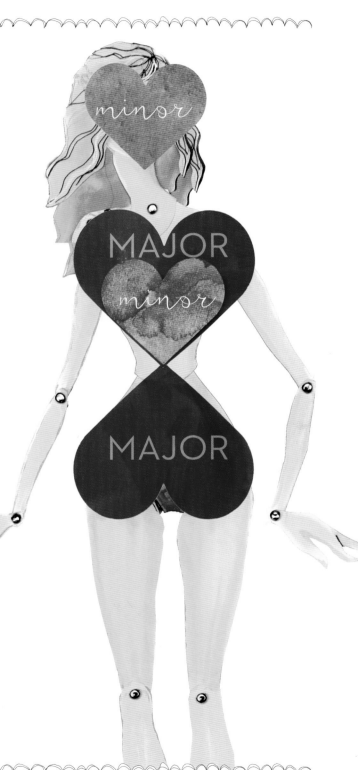

minor

MAJOR

minor

MAJOR

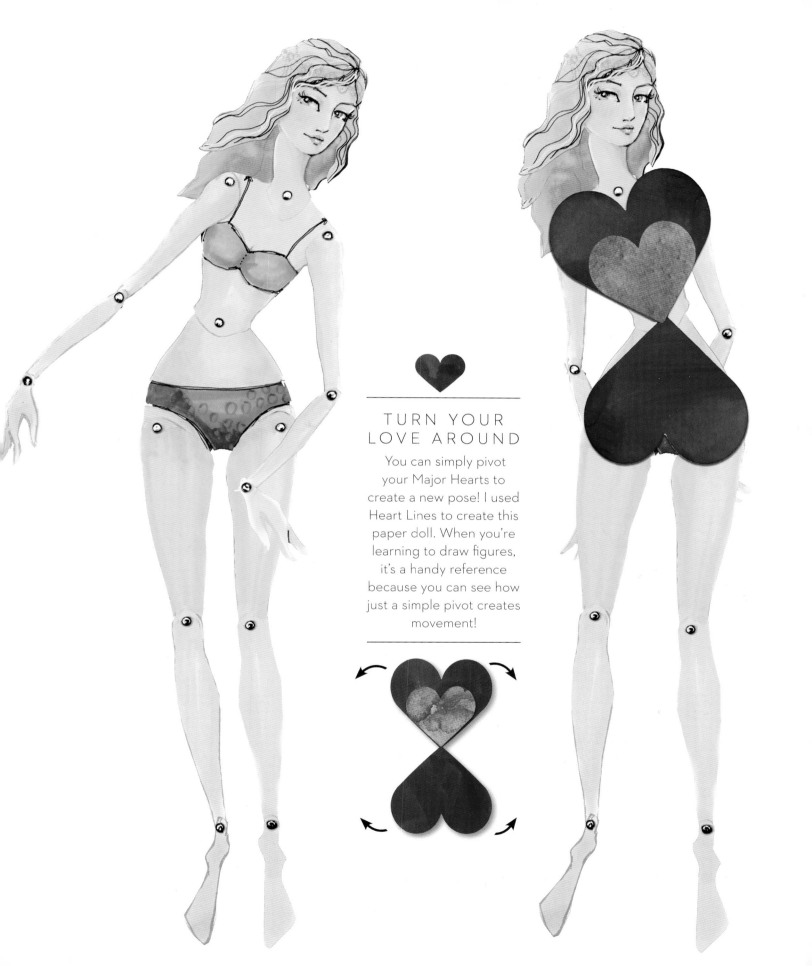

TURN YOUR LOVE AROUND

You can simply pivot your Major Hearts to create a new pose! I used Heart Lines to create this paper doll. When you're learning to draw figures, it's a handy reference because you can see how just a simple pivot creates movement!

BALANCED HEARTS

Heart Lines are intended to be a support network for your drawings, not rigid rules. This is because there is infinite variety in the human figure. However, we do need a starting point!

An easy way to remember realistic human proportions in the most basic terms is shown in the illustration on the right.

Our whole torso is equal to one of these areas:

- the upper leg

- the lower leg

- the arms without hands

Another way to look at these proportions is to envision the body folded into its most compact form! In yoga it's referred to as "child pose." Notice how it forms three almost-equal parts.

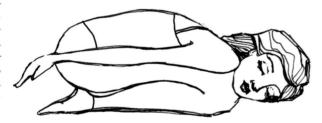

Later in the book I will show you some ideas for drawing the different shapes that make up the figure and how you can add theatrical changes to these basic proportions. But for now I just want you to grasp the general idea of our proportions.

In the **Heart Lines Map** on the opposite page I have gathered some tips as a handy reference guide.

HEART LINES MAP

The proportions shown here are approximate. They make a useful starting point.

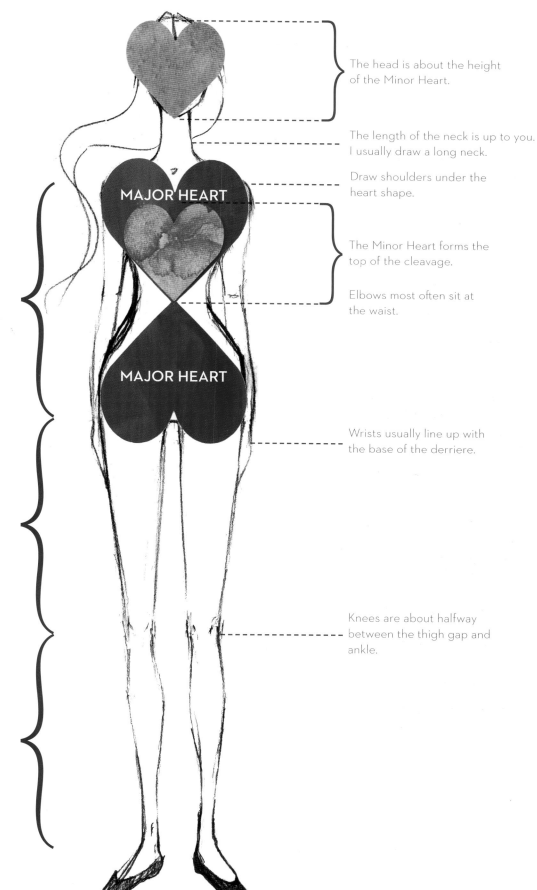

TORSO
From shoulder to thigh gap

UPPER LEG
From thigh gap to knee

LOWER LEG
From knee to top of the foot

MAJOR HEART

MAJOR HEART

The head is about the height of the Minor Heart.

The length of the neck is up to you. I usually draw a long neck.

Draw shoulders under the heart shape.

The Minor Heart forms the top of the cleavage.

Elbows most often sit at the waist.

Wrists usually line up with the base of the derriere.

Knees are about halfway between the thigh gap and ankle.

LITTLE HEARTTHROBS

**You can trace around your Heart Line templates
to create some basic practice figures I like to call Little Heartthrobs.**

1. Trace around the heart templates or hand draw your Heart Lines.

2. Connect the torso sides with two curved lines.

3. Flatten off the side of the hips rather than following the curves of the heart.

4. The neck sprouts from the middle of the upper heart.

5. Clip the top lobe of the heart away as you draw the shoulder.

 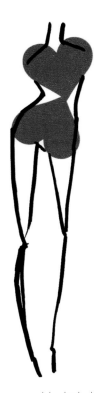 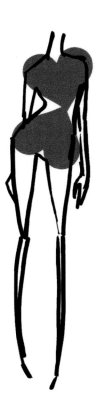 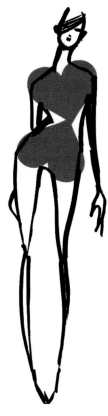

6. Draw the outer thigh coming straight down and angle the inner thigh to the knee.

7. You can add a little bend to suggest the calf muscle and thicken the feet.

8. Just like legs, keep them simple. A slight sway keeps them from looking too stiff.

9. An egg shape is fine for the head. You can add simple eyes and lips if you want!

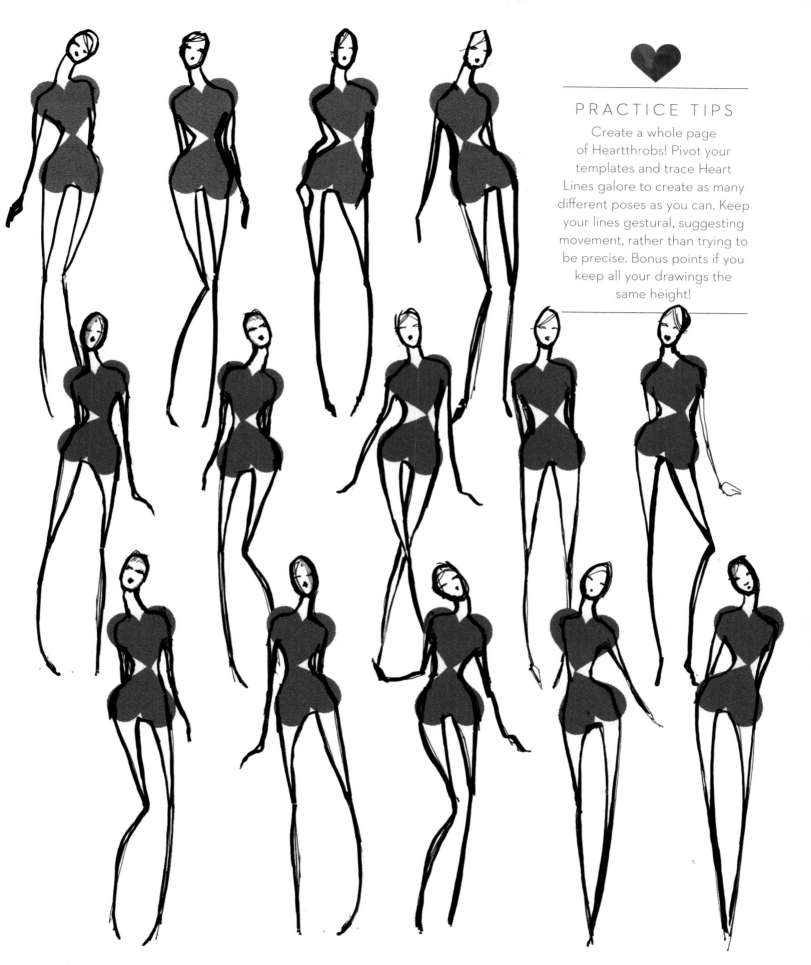

PRACTICE TIPS

Create a whole page of Heartthrobs! Pivot your templates and trace Heart Lines galore to create as many different poses as you can. Keep your lines gestural, suggesting movement, rather than trying to be precise. Bonus points if you keep all your drawings the same height!

HEART TROUBLE?

As you draw, you may come across these common conundrums. Here is how to recognize and fix them.

Wide shoulders

Arms start within that Major Heart of the upper torso—they're not attached to the outside of it. If you draw the arms next to the shoulders, you will most likely have figures that look like they can swim in the next Olympics.

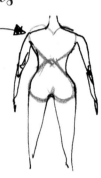

Bottom heavy

If the bottom/hips look huge, you may be drawing a too-small waist. You can build out the middle of the torso a little more or have fun creating the J.Lo/Kim Kardashian effect!

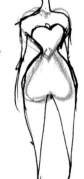

High shoulders

Remember to draw the shoulders under the tops of the hearts. If you draw the shoulders over the top of the rounded Heart Lines, the shoulders will look like they're shrugging.

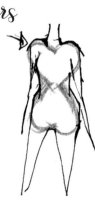

Uneven legs

I have a whole chapter on proportions coming up, but in the meantime, leg length can be a trouble area. If you're drawing several figures, it's nice if the legs all line up with each other.

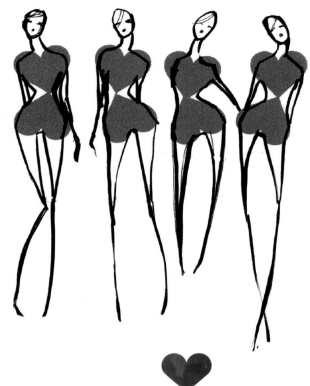

PRACTICE TIPS

Shoulders are as wide as the heart, but not the same shape. Clip a little off the top.

Arms fit within the heart. If you add them next to the heart, the body will get too wide.

Use this middle point to guide where you draw the neck.

Connect the hearts to form a waist. You can decide on the width and curve.

The thigh gap sits in the middle point of the heart.

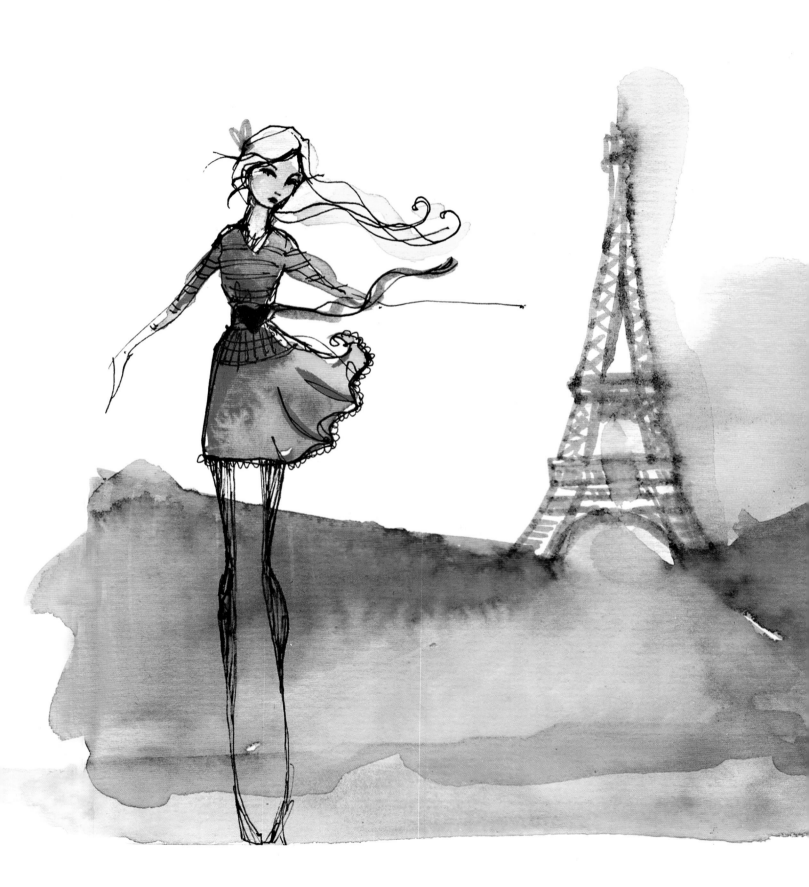

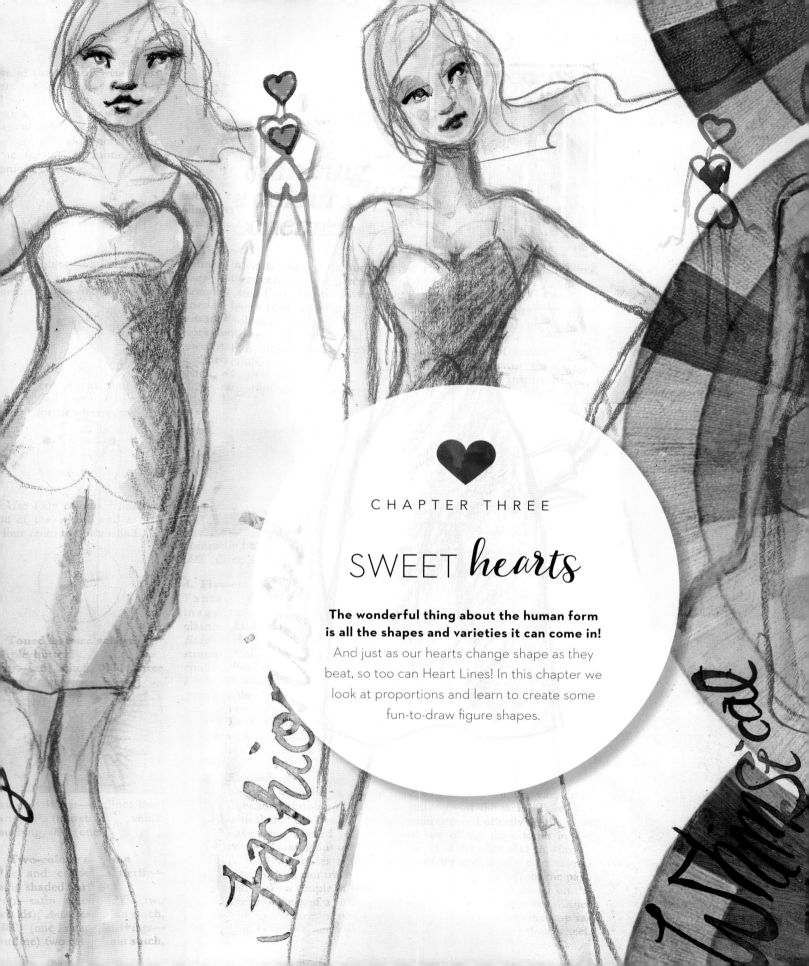

CHAPTER THREE

SWEET *hearts*

**The wonderful thing about the human form
is all the shapes and varieties it can come in!**

And just as our hearts change shape as they
beat, so too can Heart Lines! In this chapter we
look at proportions and learn to create some
fun-to-draw figure shapes.

ELASTIC HEARTS

There is no "standard person." We all qualify as human, so when I write these guidelines, they are not intended in any way to be judgmental of figure types.

Average

Strictly for the purpose of learning we have to have a starting point. I'm going to call this the **Average** figure.

This includes the drawings we have been working on so far.

Fashionized

The wonderful thing about Heart Lines is that they can be pushed and pulled like elastic to help make a wonderful variety of figure types!

For example, to make a very slender figure, we can squeeze the torso hearts inward to help us draw a narrower body.

The head heart does not get reduced, because skulls don't get skinnier. The facial features do become more refined.

I call this type of figure **Fashionized**.

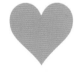

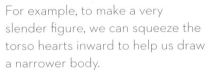

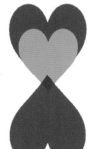

Juicy

To draw a larger figure, we can expand the hearts that make up the torso outward.

As with the Fashionized figure, I leave the head heart the same and add more volume to the facial features.

I call this figure type **Juicy**.

Kiddo

By shrinking the torso hearts we can create a child. Of course this encompasses a rapidly growing and changing body, but there are principles we can use to guide us. I call this type of figure the **Kiddo**.

Whimsical

By pushing and pulling the Heart Lines we can create more fantastical people!

Just by making the head heart bigger, we add a dynamic tension to our drawings!

I call this a **Whimsical** figure.

On the following pages I have more specific details for each figure type.

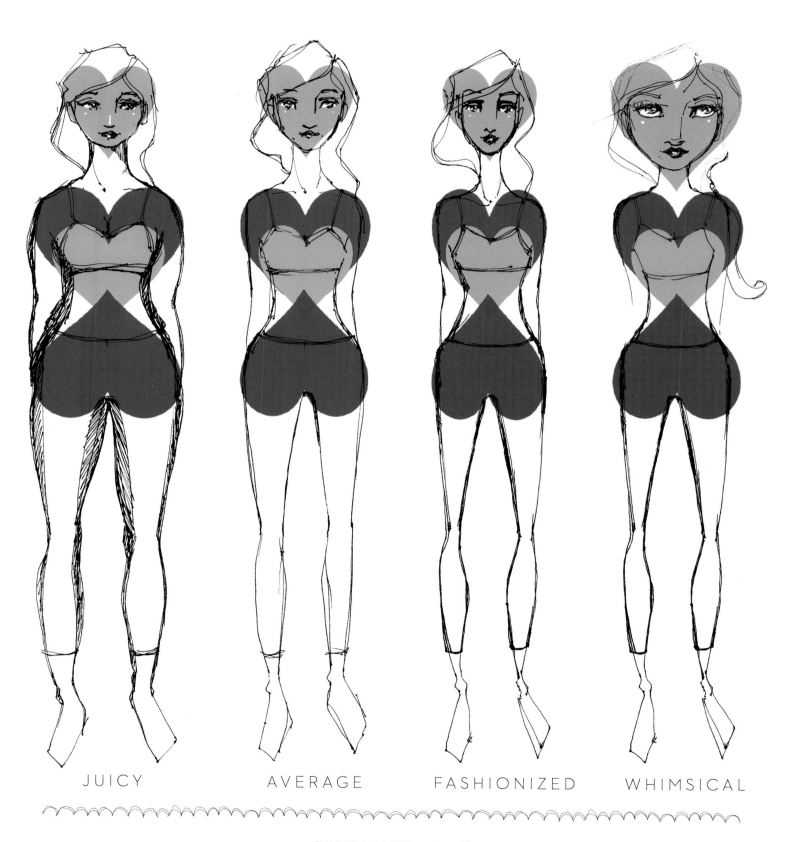

JUICY AVERAGE FASHIONIZED WHIMSICAL

JUICY FIGURE

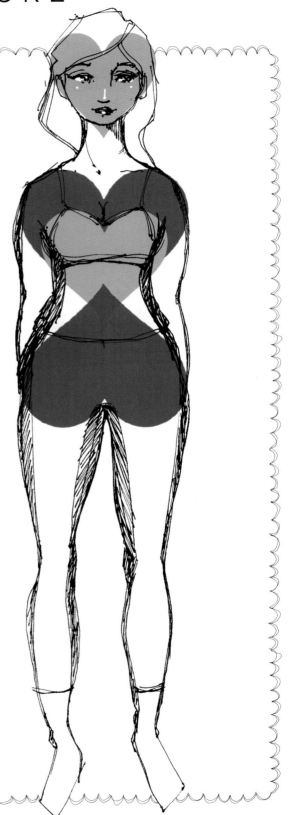

I love drawing curves! And the fuller, or Juicy, figure, is wonderfully fun to draw. Each person carries extra weight a little differently, so these really are just guidelines to try for yourself:

- Try drawing a softer jawline and slightly fuller neck.

- Rather than make the shoulders broader, add to the arms themselves, especially the upper arm.

- To create the illusion of a bigger bust, emphasize the *Y* shape to form a deeper cleavage.

- You can indicate a fuller waist by including a little "roll."

- When drawing clothes, bend the lines that cross the waist to give the illusion of more substance.

- Because of the way our pelvis is shaped, our hips usually flatten at the sides, even on a Juicy figure.

- Inner thighs can touch.

- Outer thighs can have more curve.

- The leg narrows at the knee, but you can give extra curve to the inside of the knee.

- Emphasize calf curves and narrow legs to the ankle.

- Hands and feet may get fuller and have more curves, but they don't get longer.

The real fun of drawing the Juicy figure is when it's time to start shading. All those curves allow you to build lots of volume. We'll learn more about shading later in this book.

FASHIONIZED FIGURE

I absolutely adore fashion illustration, and you can see that affinity in my elongated figures. The Fashionized figure emphasizes height and slimness, which you can show with these tips:

• Draw a more angular jawline and slightly longer neck.

• Emphasize clavicles (collarbones).

• You can choose to draw the bust small or make it larger just by adding a little *Y* in between.

• Avoid drawing lines on the torso to indicate ribs and abdomen, as it's best to do that with shading.

• When drawing clothes, straighten the lines that cross the torso to keep the illusion of less flesh.

• Because of the way our pelvis is shaped, our hips usually flatten at the sides even more so on a very slim figure.

• Emphasize the thigh gap.

• Keep outer thighs straight and angle the inner thigh toward the knee.

Drawing a really long neck, arms, and legs is one fun way to take your drawing into fashion fantasy! I find that as long as I keep them all long, but still follow the other Heart Lines for the torso and head, the figure will still look balanced.

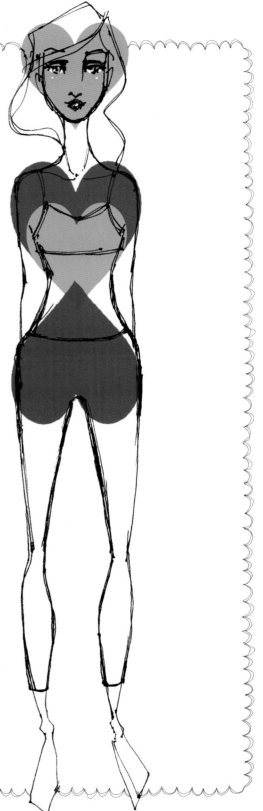

WHIMSICAL FIGURE

Eyes are the windows to the soul, and having a larger head to work with makes them even more fun to draw. Growing up, most of my dolls had enormous heads, so maybe that's one of the reasons they just look "right" to me!

I'm also rather addicted to all things cute and love to borrow elements from girlhood and blend them into my drawings. I call this style of figure drawing "whimsical," and it is VERY open to interpretation. This is where you can play with Heart Lines to create your own reality.

Here are some starting points:

- I make the head larger, sometimes as big as the Major Heart. But you can make the head way larger than that.

- I love to tilt the head. It adds instant movement to the drawing and a curve to the neck. A tilted head symbolizes listening, dreaming, and thinking to me.

- I make the neck long, as it adds fragility.

- To keep the emphasis on the eyes and face, leave the details to those areas only so they draw all the attention.

- You can borrow a wildly elongated neck and limbs from the Fashionized figure to add drama.

Once you understand proportions, have fun and experiment with them! Try mixing your Elastic Hearts! For example, pair Fashionized shoulders with Juicy hips.

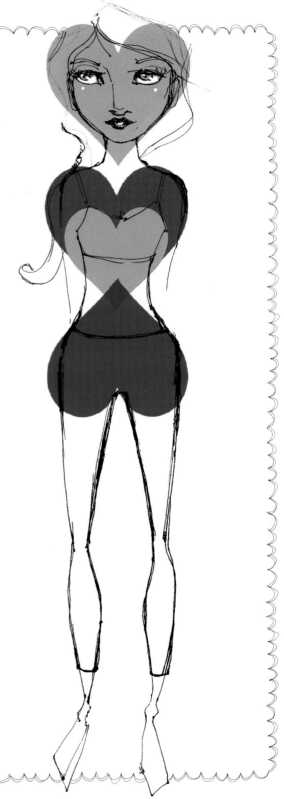

KIDDO

Heart Lines work on girls as well! The main thing to consider is that our heads are quite large proportionally as babies, and as we travel through childhood to adulthood, our bodies have to catch up.

This book doesn't delve into drawing children in detail, but I did want to give you just a few starter tips!

- The way I approach drawing children using my Heart Lines is to use a smaller set than I would for an adult. How much smaller depends on the age of the child.

- I then draw the figure without curves, as they are the telltale signs of puberty.

- I keep shoulders and arms within the heart, as I would for an adult, but then keep the waistlines straight.

- I don't draw the swell of the hips we usually get as adults, and keep them straight. I keep the limbs fairly angular also.

- As with drawing a Whimsical figure, I like to emphasize the head and fragility of the figure, so I usually draw necks a bit longer. Drawing is theater, and you can add your own twist to what you create.

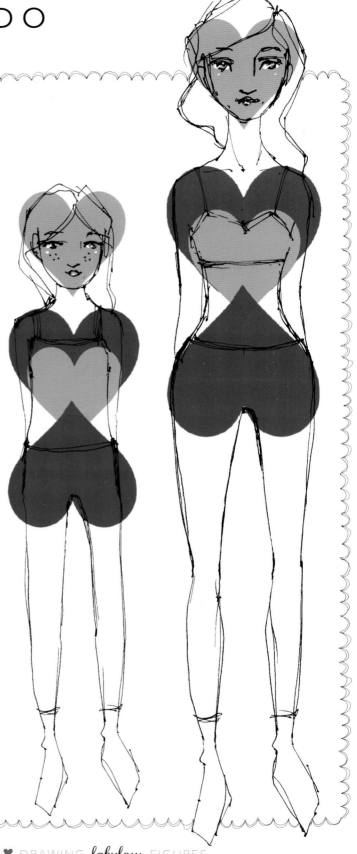

Take the Lolly Legs out for a power pose! If you pop the hands on the hips, you'll have a superhero stance.

Take your Lolly Legs to a slight lean to make the figure look like she's swaying, or about to walk somewhere.

Try crossing the legs to give the simple illusion of walking.

Sweep your girls off their feet by taking the Lolly Legs to a crazy angle!

HIPS & HEMS

Another fun way to add movement is by emphasizing the movement of the hips! We can do this by drawing a simple dress.

1. Take your heart templates and pivot the lower ones. Sketch a Little Heartthrob figure. Notice the angle that the lower heart forms.

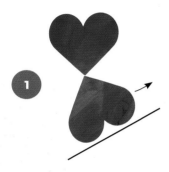

2. Draw a hem line that is parallel to the lower heart. See how it already emphasizes the movement? If you draw this line with a slight curve in it as I have done, it has a more pleasing effect.

3. Connect the hip lines to the hem to form a simple skirt.

4. Block in some color to form a simple dress. If you leave the hem straight like this, it will look as if the dress is made from a stiff fabric.

5. Add a little movement to the hem and the dress to make it look as if it is made from a fluid, soft fabric and appears to almost move.

Practice on a small scale, and then try the same principle with Water Drawing!

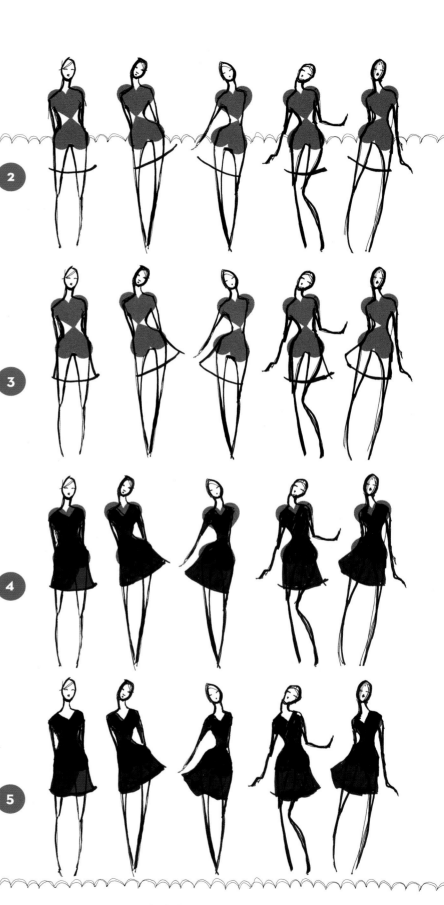

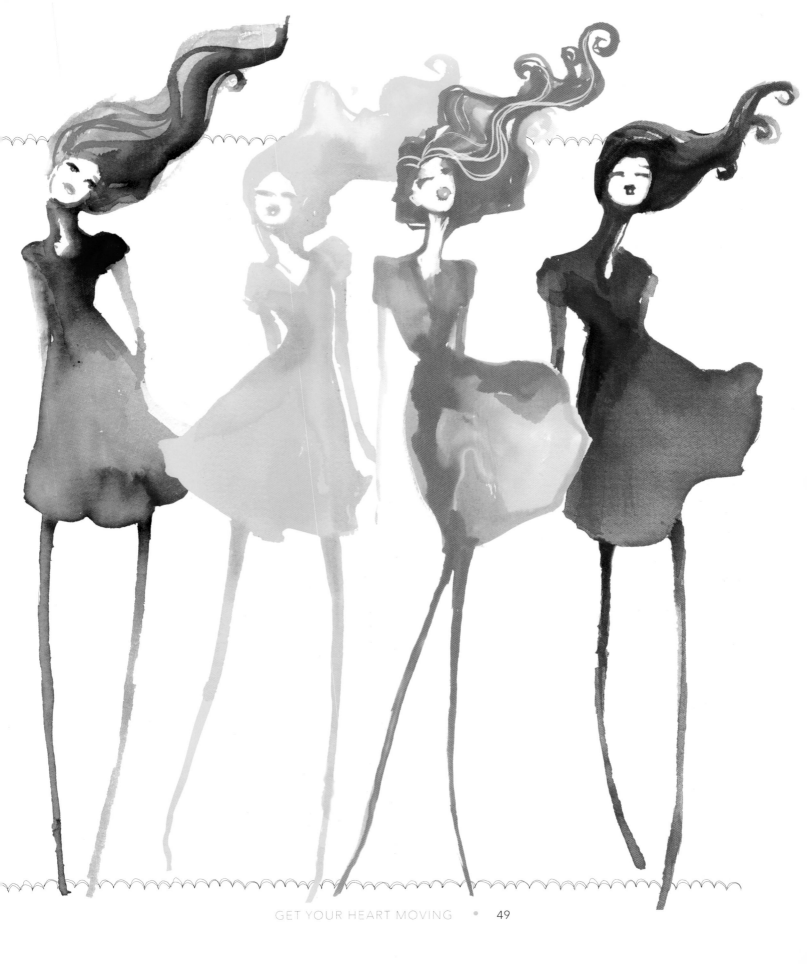

BEND THE RULES

Adding a bend in the arm or leg is another tool you can use to create instant dynamism in a pose.

Leg bends

In simplest terms, you just need to bend a Lolly Leg in the middle. This is because our knees sit roughly halfway down our legs. I suggest you play with various degrees of bends and see just how versatile this simple movement can be!

Arm bends

I have hardly mentioned arms in the book so far. Our arms and hands are essential parts of our body language. I tend to downplay them in drawings because they can take over the page very quickly!

I will go into arms in great detail later in this book, but for now you can try the Lolly Legs principle with arms. Points to remember are that the elbows sit at roughly the waist and are halfway between the shoulders and wrists.

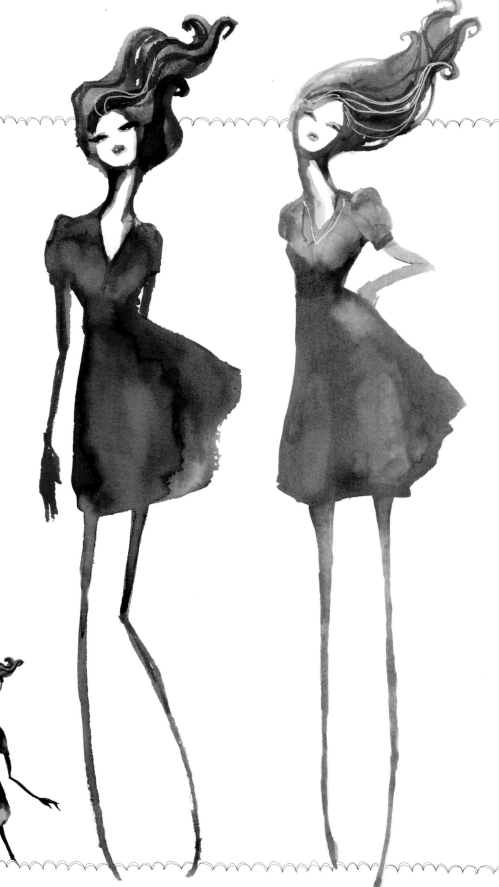

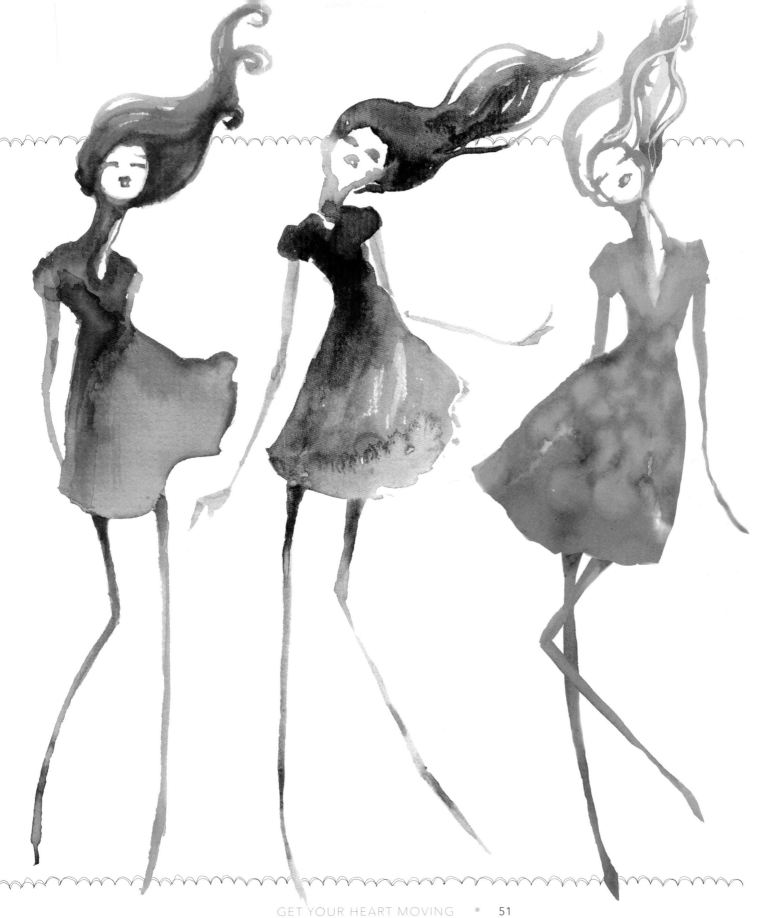

MOVING
PIECES

Even with these simple figures, we can make them walk! All we need to do is make one leg look like it is farther away from the other.

There are a few ways to create this effect.

Balancing act
Swing an arm out to balance the body.

Do the flip
Emphasize the flip of the hem to add velocity to the movement!

Shadow play
Make the leg that is farther back darker in color or shade. This gives the optical illusion of pushing it back into the paper.

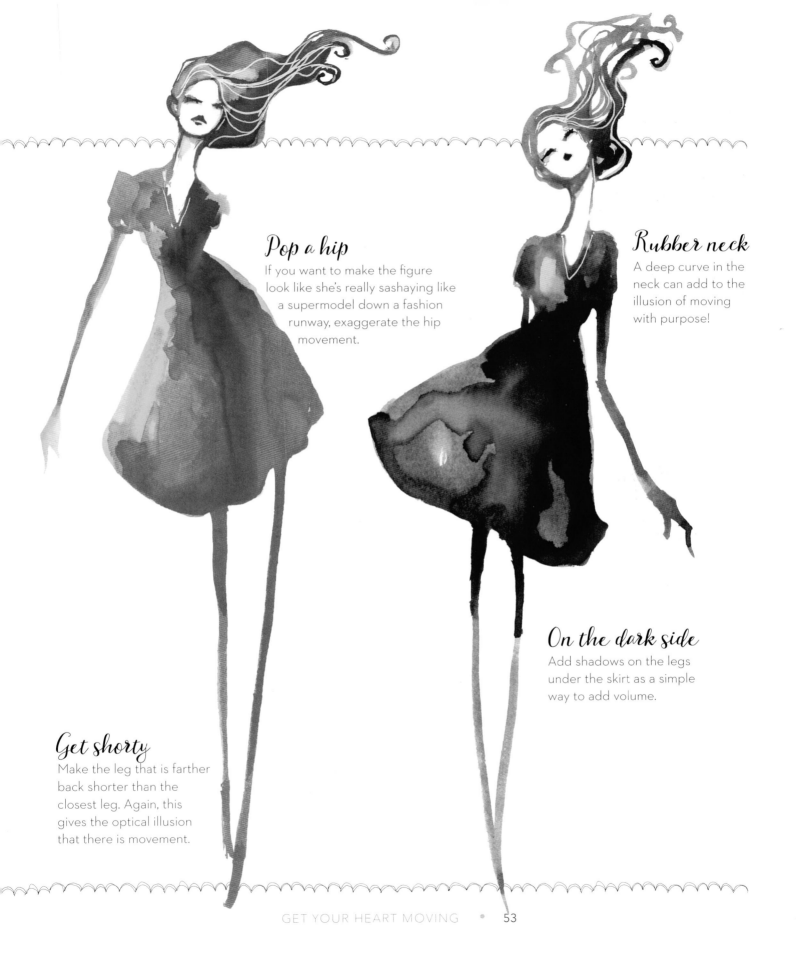

Pop a hip

If you want to make the figure look like she's really sashaying like a supermodel down a fashion runway, exaggerate the hip movement.

Rubber neck

A deep curve in the neck can add to the illusion of moving with purpose!

On the dark side

Add shadows on the legs under the skirt as a simple way to add volume.

Get shorty

Make the leg that is farther back shorter than the closest leg. Again, this gives the optical illusion that there is movement.

TWIST & TURN

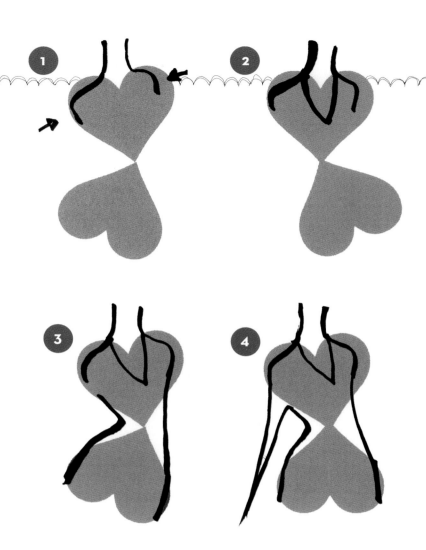

Let's add a little twist to the plot!

We can give the illusion that the body is turning with a few simple changes. In this example, all I am twisting is the upper torso. There are some fiddly parts to this, so pay attention!

1. Decide which way you're going to turn the upper torso and draw the far shoulder as being smaller.

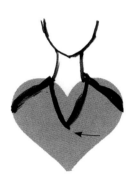

2. Clothing the figure with a V-neck neckline is the easiest way for me to demonstrate the subtle but important change in the chest. Swing the bottom of the neckline from the center toward the short shoulder.

3. Connect your shoulders to the hips. You can leave a gap to fit the arm in if you like.

4. As the body turns, one arm disappears and one becomes more prominent. In a simple drawing, you can draw just the prominent arm.

5. If you want, you can add a little swell to indicate the bustline. Just keep in mind where the Minor Heart sits to help with placement.

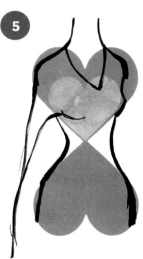

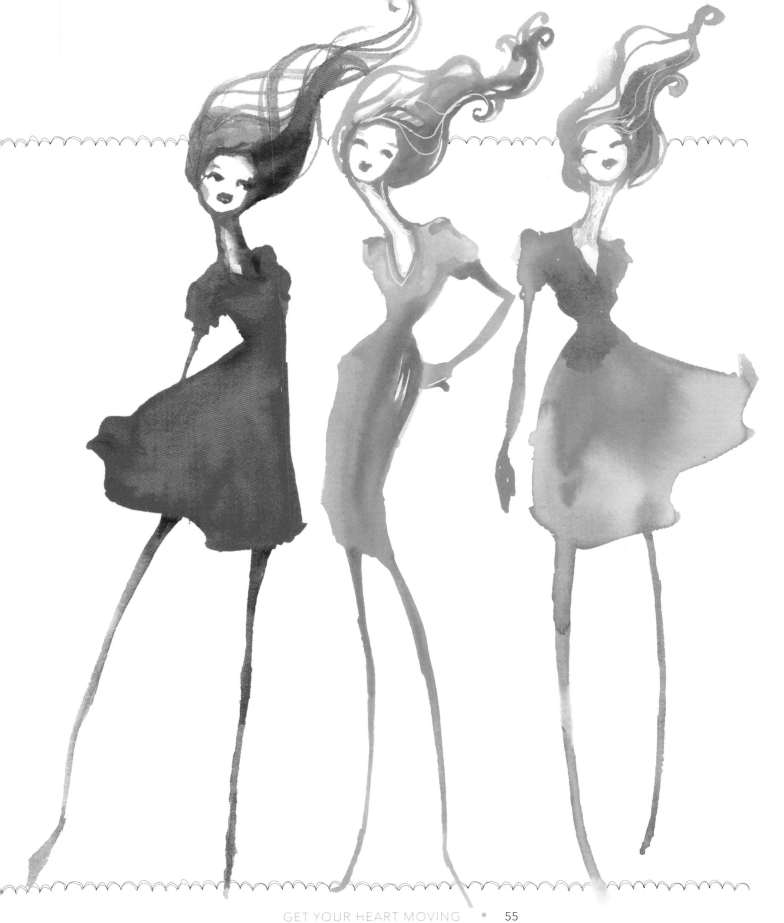

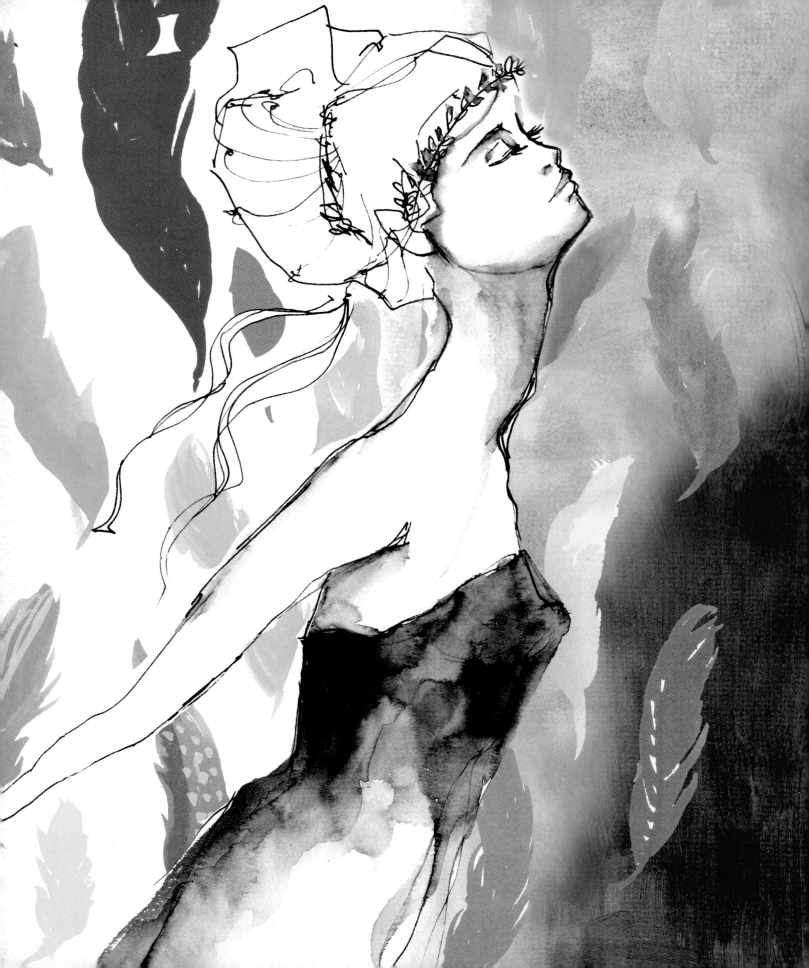

CHAPTER FIVE

HALF *hearted*

**Drawing the figure in profile is an easy way
to add dynamic movement to your artwork.**
By turning the figure we get the sense
that the subject is on her way somewhere
else. Heart Lines can help you create the
sideways view that adds a whole new way of
expressing yourself visually!

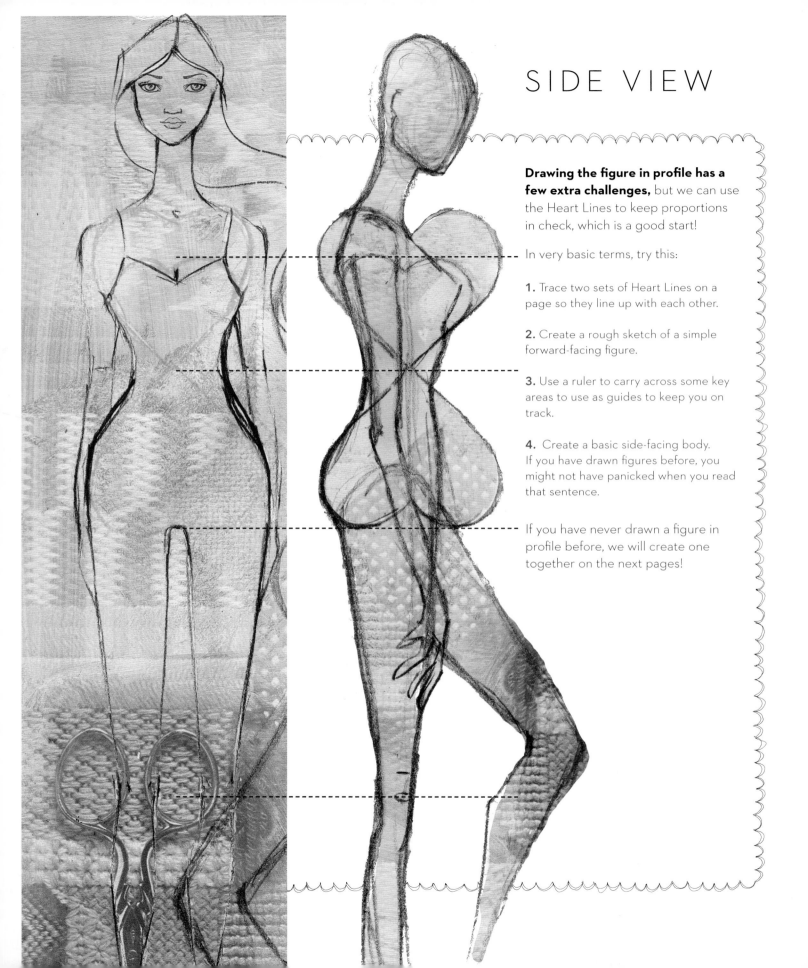

SIDE VIEW

Drawing the figure in profile has a few extra challenges, but we can use the Heart Lines to keep proportions in check, which is a good start!

In very basic terms, try this:

1. Trace two sets of Heart Lines on a page so they line up with each other.

2. Create a rough sketch of a simple forward-facing figure.

3. Use a ruler to carry across some key areas to use as guides to keep you on track.

4. Create a basic side-facing body. If you have drawn figures before, you might not have panicked when you read that sentence.

If you have never drawn a figure in profile before, we will create one together on the next pages!

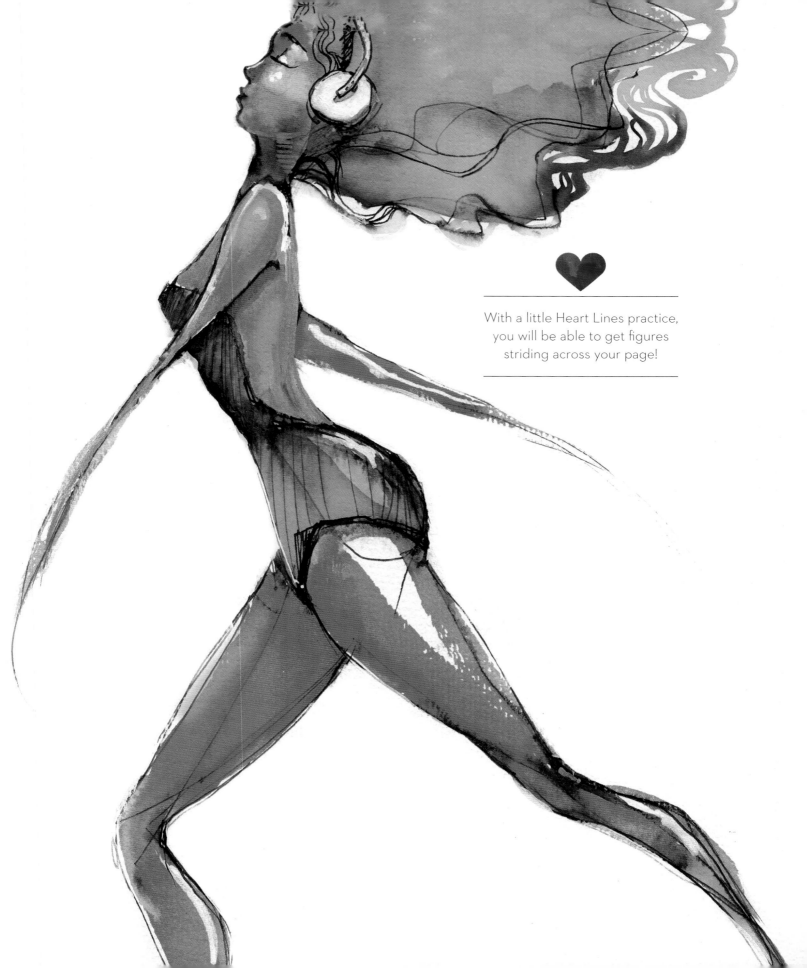

With a little Heart Lines practice,
you will be able to get figures
striding across your page!

SIDE STEPS

Heart Lines can help you form the basics of the figure in profile:

1. In profile, draw the neck off center with a forward slant.

2. Add a dot in the center of the Minor Heart and on either side at the same level.

3. Draw a line from the front of the neck to the dot at the front of the body and down to the waist to form the chest. Continue that line down to form the front of the stomach.

4. To form the back, start from the neck and draw the angle of the shoulder blades. Indicate the small of the back by curving your line in between the two hearts. Use the lower heart to help you form the buttocks.

5. To draw the arm, use the two remaining dots as your starting points. Angle down toward the elbow, which sits just below where the two Major Hearts meet. The forearm is the same length to the wrist.

6. The back of the leg is a straight line, while the front has more of a curve. Both angle in toward the knee.

7. Reverse the curves you drew for the upper leg for the lower leg.

8. Place the ear in the middle of the Minor Heart used for the head.

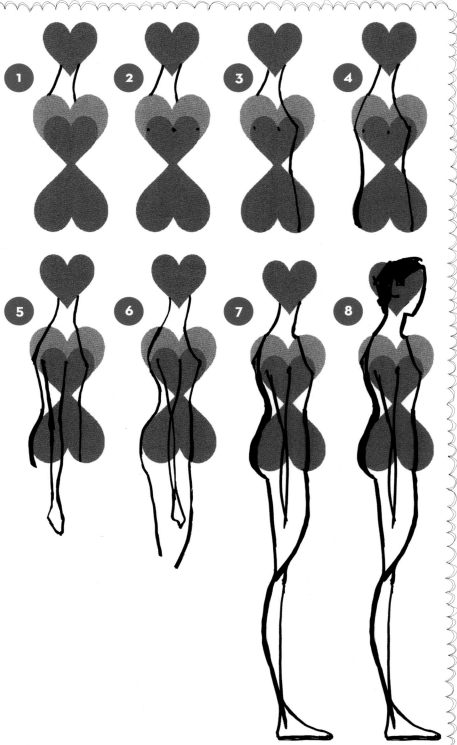

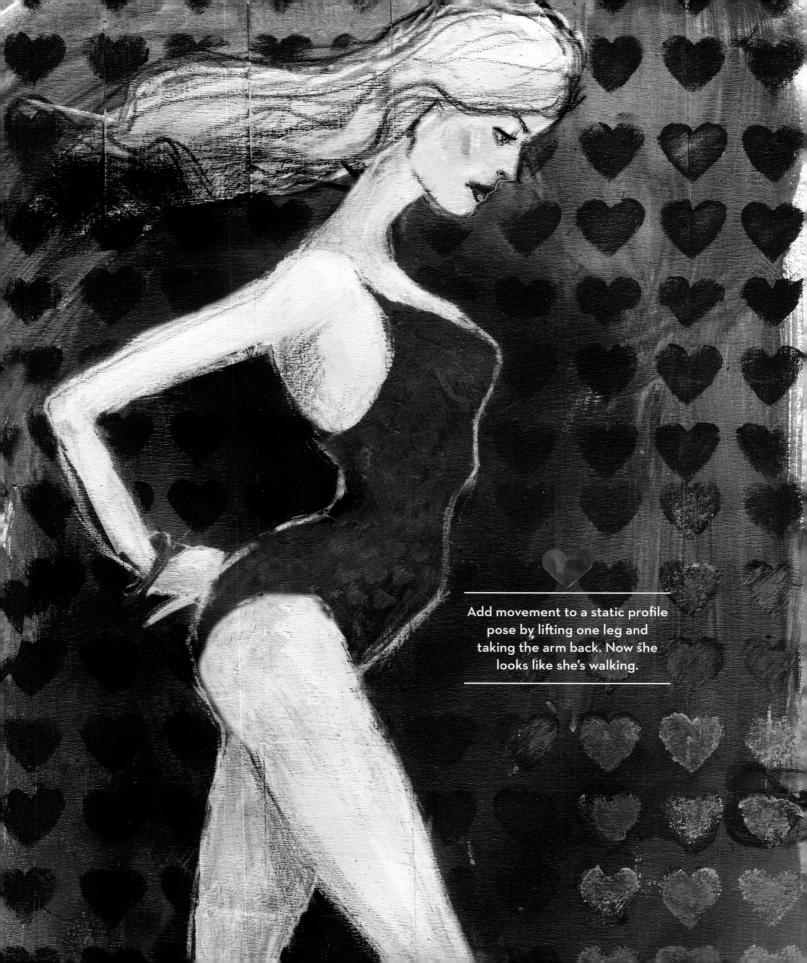

Add movement to a static profile pose by lifting one leg and taking the arm back. Now she looks like she's walking.

SWING IT

To get the Side Steps figure moving, all you need to do is swing the arms and legs.

1. Start the same way as for the Side Steps (static) figure. The only difference is the three little dots across the chest you added for the static figure. For this figure we only need the center dot.

2. That center dot is the approximate start of the underarm. Use it to locate and start to draw the arm as it swings back.

3. As the arm swings back it hides the shoulder blades from view. You can indicate the top of the shoulder with a curved arc.

4. With the arm in place, you can continue drawing the back and bottom.

5. Keep things simple by drawing fairly straight legs. Using the same method as Side Steps, draw the front striding leg at an angle. Then draw the other leg with the same method, just at the opposite angle.

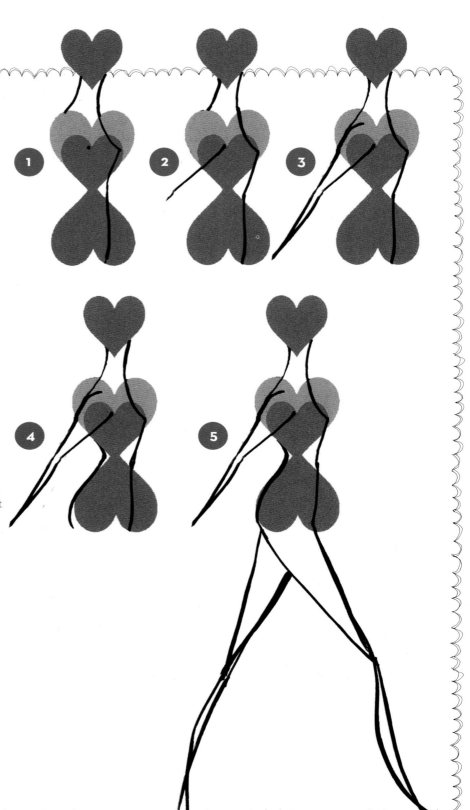

LEAN IN

Now we get to the profile view that I adore drawing most! I call it **Yearning Pose,** because the figures have so much dynamic tension in them!

24.5 °

1. Stack up your Heart Lines templates, then tip them over at the desired angle. In this example it's 24.5 degrees, but you don't have to be this precise!

2. The Minor Heart for the head stays put. Or you can tip it the opposite way a fraction. This will help you draw the head with the chin lifted up a little. It's a small movement that can emphasize the lean!

3. Look at how the neck position changes the lines coming from the head, off to one side. It attaches to the body in the same way.

4. Construct the upper body as you did under Twist & Turn (page 54).

5. To give the illusion that the lower torso is twisting away as well, cut off some of the front hip.

6. Tilt the neckline at an angle.

7. Draw the head. (Don't worry! We have lessons on that coming up next!)

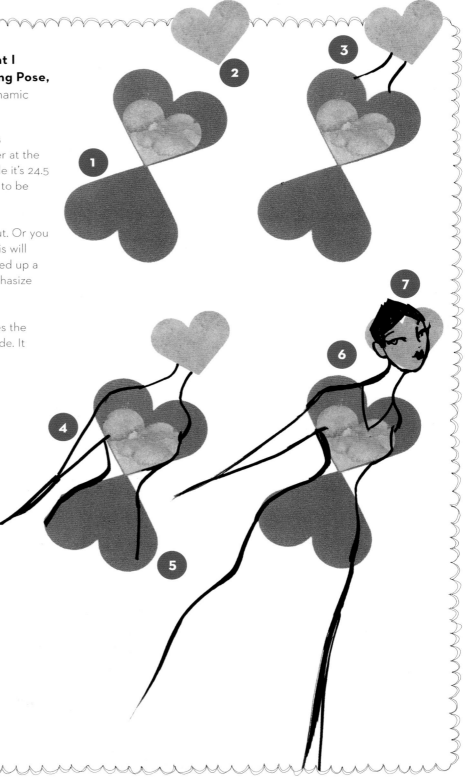

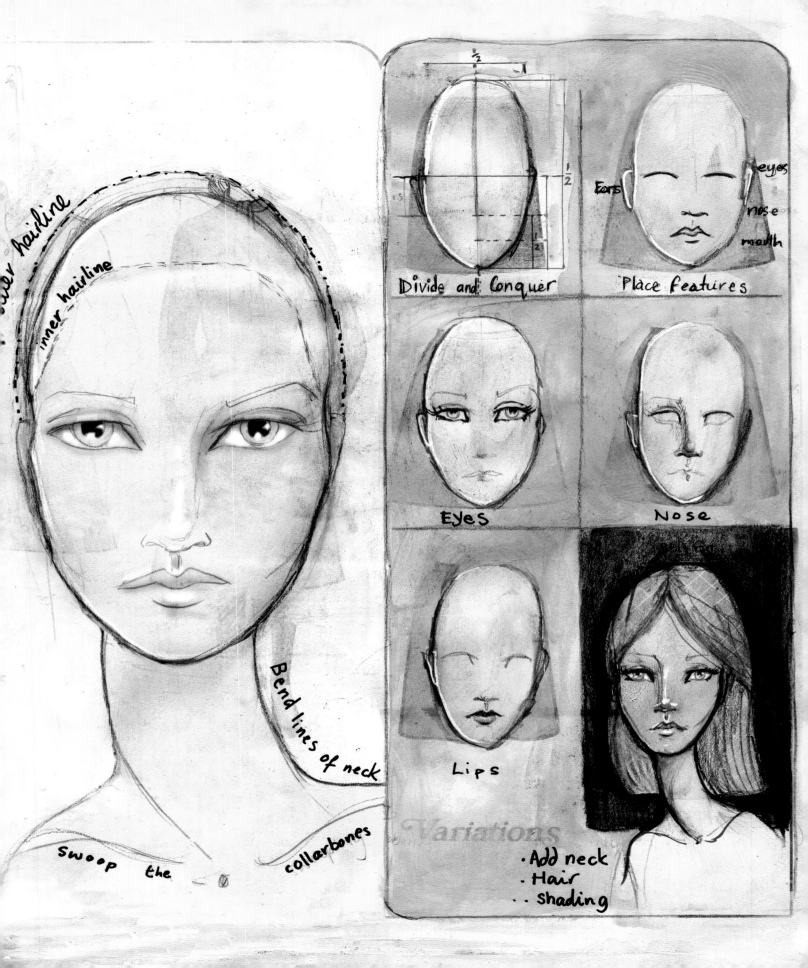

outer hairline

inner hairline

Bend lines of neck

Swoop the collarbones

½

½

·5

2

Divide and Conquer

Ears

eyes

nose

mouth

Place features

Eyes

Nose

Lips

Variations

·Add neck
·Hair
··shading

REFINING FEATURES

Here are some exercises to help you get down to the bare essentials!

Be a dropout

Draw a few ovals in decreasing sizes, making the first one a size you would usually draw a face.

On the largest oval, include all the features in as much detail as you like.

When it comes to the next oval, see what details you can leave out and still get a drawing you like.
As you create smaller and smaller faces, keep eliminating details.

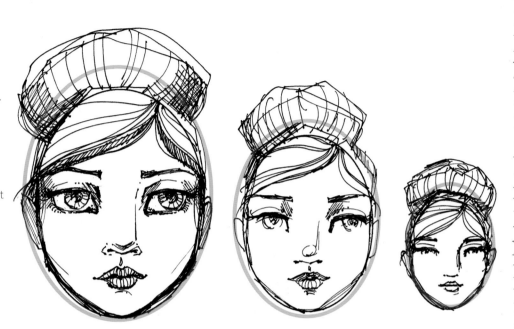

Line it up

Start with an oval and use a ruler to carry a line across your page for each of the facial features.

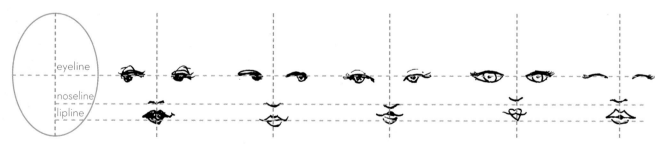

On the eyeline, create lots of simple types of eyes.
On the noseline, sketch different noses. Experiment with placement above, on, and below the line.
On the lipline, try drawing a variety of lips. Draw them in different widths and different positions.

TURN THE CHEEK

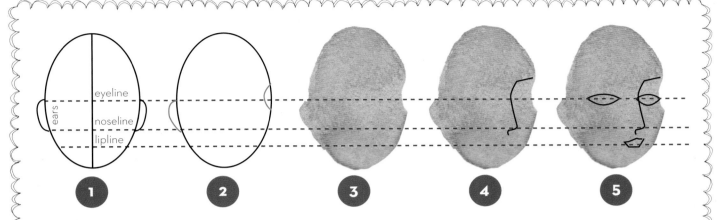

1 **2** **3** **4** **5**

I could write a whole book just on drawing a turned face because of the sheer variety and complexity (although you don't need an entire book!). This method is what I use to create small, turned faces.

1. Start with drawing an oval. You can add your key lines as practice.

2. On another clean oval you're going to add and take away. As the face turns, the eye socket and ear become prominent. You can create an eye socket by carving out a little section at eye level. Add the ear between the eye- and noseline.

3. In either watercolor or acrylic, paint that odd shape. Does it need to be perfect? NO! On the opposite page you can see my examples and that each one is a little different. This leads to lots of variety!

4. I like to start with known entities, and we have the eye socket to guide placing the eyebrow, which sits above it. With a black pen, start a line at the outer edge of the eyebrow, which runs into the bridge of the nose. The nose ends at the same point as the forward-facing face. I call this the **Hi-brow Line**.

5. Lips sit under the nose. Eyes sit on the eyeline. The eye farthest from us gets tucked behind the nose a little.

6. The rest is just details! As practice, create lots of small turned faces on a page in lots of different colors. As you draw the details with a black pen and a white paint pen, you can play with placement of features and see how little changes can create a whole new person! I have more tips on details in the next section.

6

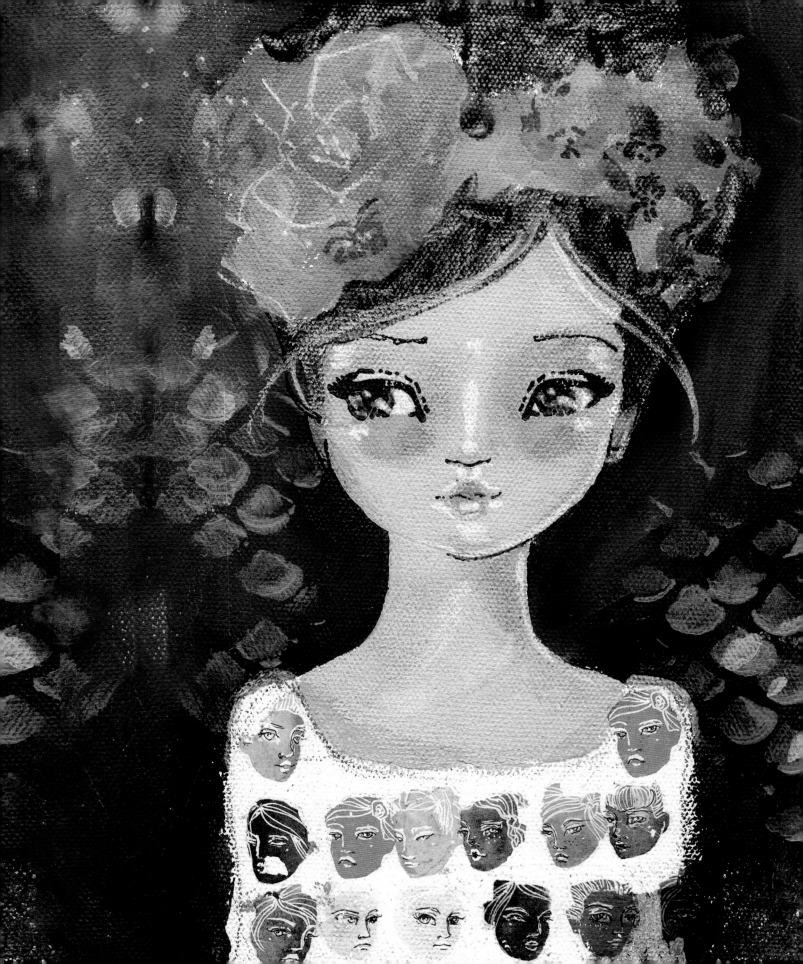

BE THE HAIR

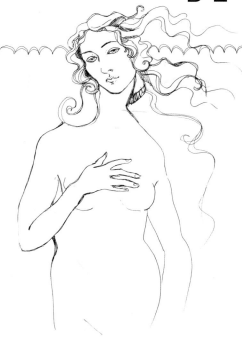

The artist who has had the greatest influence on my work is Botticelli. I am entranced by his quirky proportions, soft yet powerful palette, and lyrical movement. That influence is expressed in many ways in my work, but swirling hair and long necks are the most obvious. I feel that drawing movement into the hair adds immediate life to a drawing.

"Be the hair." My online students hear me say this over and over. It means start drawing the hair from where it grows at the root and follow along until you get to the tip. For a start, hold your drawing tool more loosely and near the tail end so you get more erratic, gestural lines.

To break it down into steps:

1. Define the hairline as you did in the previous pages.

2. Extend the Hairline to create the hair direction. I like to have the wind gently blow the hair all in one direction. So one side will have hair extending out, and the other will have hair flowing behind the head.

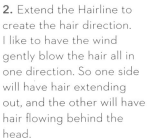

3. Now define the bulk of the hair by drawing a curved line to connect the container with the tip of the hair.

4. Starting from the part, draw the hair the way it grows from the root, flowing to the tips.

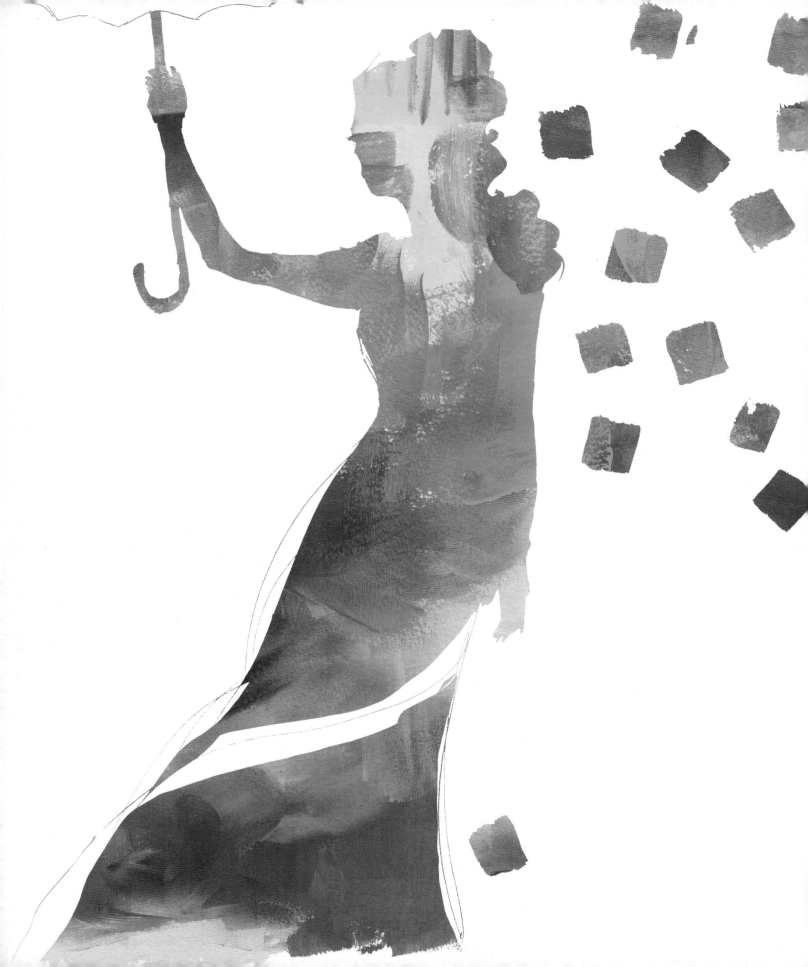

CHAPTER EIGHT

BODY *of work*

There is no substitute for drawing from real life to really teach you how to recreate the human form. But that doesn't mean I can't distill what I have learned over the years and create a few shortcuts for you. In this chapter, I have my secret tips and techniques for drawing details. These can really help you build some nuanced and realistic elements into your figures.

NECK & NECK

The neck is a wonderful place to add movement into a drawing. My style calls me to elongate and exaggerate the neck, as I feel it heightens fragility and adds dynamic tension. You may not want to go to such lengths, but you can still use my examples to add a little movement. I always start by drawing the jaw and chin first, so I know which way the face is turning, and then decide where to place the neck.

The chin is the most useful feature for placing the neck. For a straight-facing head, the chin and neck are centered, but you can easily add some dynamism by shifting that arrangement!

I have three neck poses for you to try.

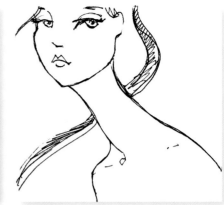

THE LEAN: To make the head look as if it's leaning forward, draw the jaw and place the front neckline behind the point of the chin. This pose makes the figure looks like she's on the move, or yearning to go somewhere.

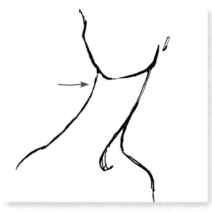
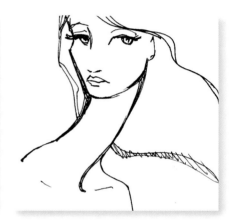

THE SWAY: To make the head look as if it's leaning back, draw the jaw and place the back neckline to the left of (in front of) the point of the chin. This pose makes the figure look hesitant or thoughtful.

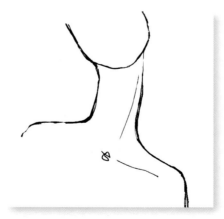
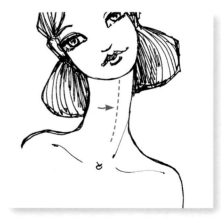

THE TILT: I love this whimsical pose! The trick is to get the neck positioned properly. First draw the head at a tilt. Add the neck so the point of the chin is closer to the tilted side than the center (red dashed line).

ARMS RACE

The most important thing to keep in mind when drawing arms is the placement of the joints. The elbow sits at the halfway point between the shoulder and wrist.

In this walk-through I'm sticking to realistic proportions, but you can exaggerate arm proportions away from these guidelines. As long as the elbow sits halfway on the arm, the proportions will look fine.

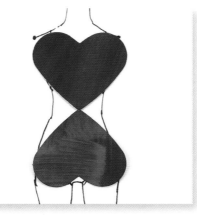

1. Remember that the shoulders and upper arms fall within the Heart Lines.

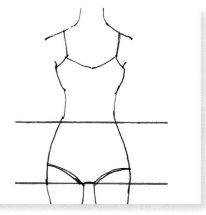

2. There are two points that will help you get arm proportions: one at the waist and one at the base of the torso.

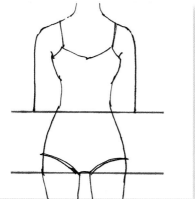

3. The upper arm drops to the waistline, which is where the elbows are usually placed.

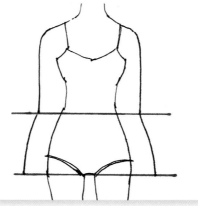

4. The forearm has a slight curve and drops to the torso baseline. Add some natural movement by angling outward.

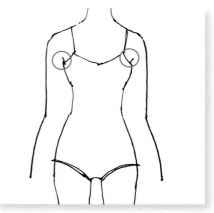

5. The two tiny lines circled here indicate the armpit and can help you position the underside of the arm.

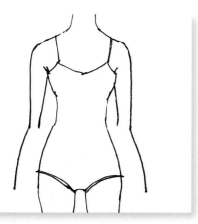

6. I like to draw the underarm with a slight curve in it and narrowing toward the elbow.

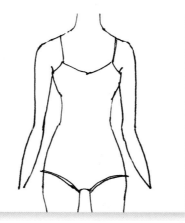

7. Carry the line on to the wrist. You can add some curve and narrow it at the wrist.

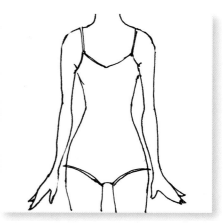

8. To finish, give yourself a hand. (I'll show you how next!)

HANDY
REFERENCE

Here are three hand poses you will find very useful.

They will add variety to your figures and give them something to do!

The pinch

Start with Pyramid Hands, but simply place the accent fingers fanning up and behind the hand.

This pose is handy if you want your figure to be holding something.

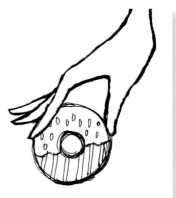

The clutch

Again, start with Pyramid Hands, but here you move the thumb a little farther out and curl the fingers a little more.

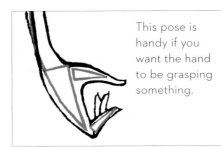

This pose is handy if you want the hand to be grasping something.

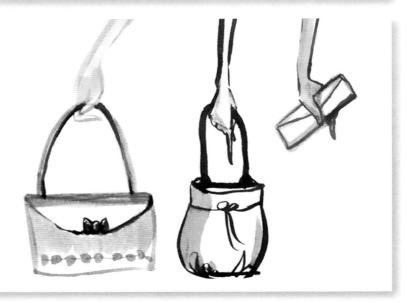

Power pose

Here we use more of a block shape and don't worry about fingers, as they are hidden in the fist. This hand pose indicates surety and confidence.

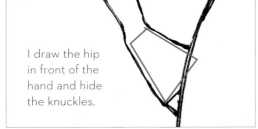

I draw the hip in front of the hand and hide the knuckles.

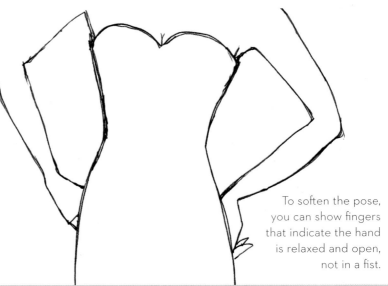

To soften the pose, you can show fingers that indicate the hand is relaxed and open, not in a fist.

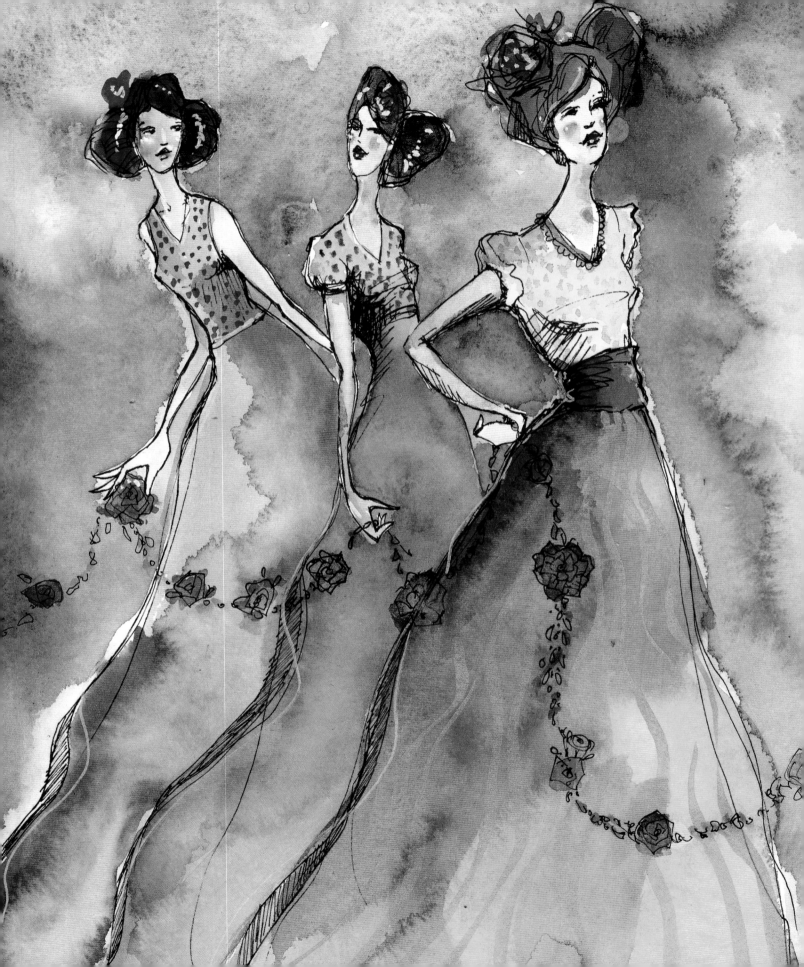

FINGER TIPS

I strongly believe it's important to practice drawing more complex hand poses by looking at a reference: a photograph, in a mirror at your own hands, or ask someone to hand model for you. And the sole reason for this is FINGERS.

As soon as you add fingers to a drawing in any detail, they become incredibly visually arresting because all the little fingers lines form patterns, and our brains love deciphering patterns.

As you would expect by now, I have a few shortcuts for you!

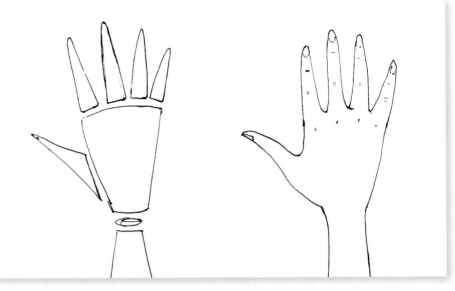

Our hands are amazing; there are so many pieces to them. Even each finger is a different height and shape! The more detail you add to your drawing, the more realistic it will become, but your drawing will quickly be all about the hands. It's also very hard to let hand imperfections survive on the page, but a little chaos can be endearing!

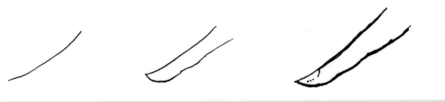

I like to get a little theatricality into the hands, so I add a bit of sway to the top side of the finger. Add a little meat to the underside of the fingertips so they don't get too pointy and witch-i-poo. A hint of nail bed is all you need.

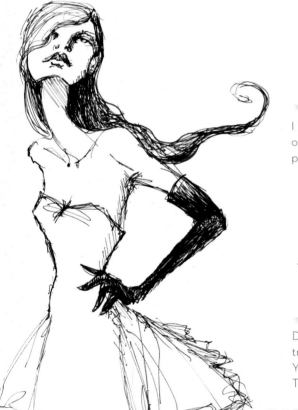

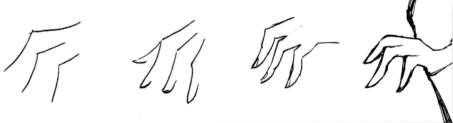

Drawing a more complex hand from your imagination takes some muscle memory. To train for that, take some tracing paper and trace hands from a magazine or newspaper. You want to get them down to the simplest form while still remaining expressive. That's how I drew this hand.

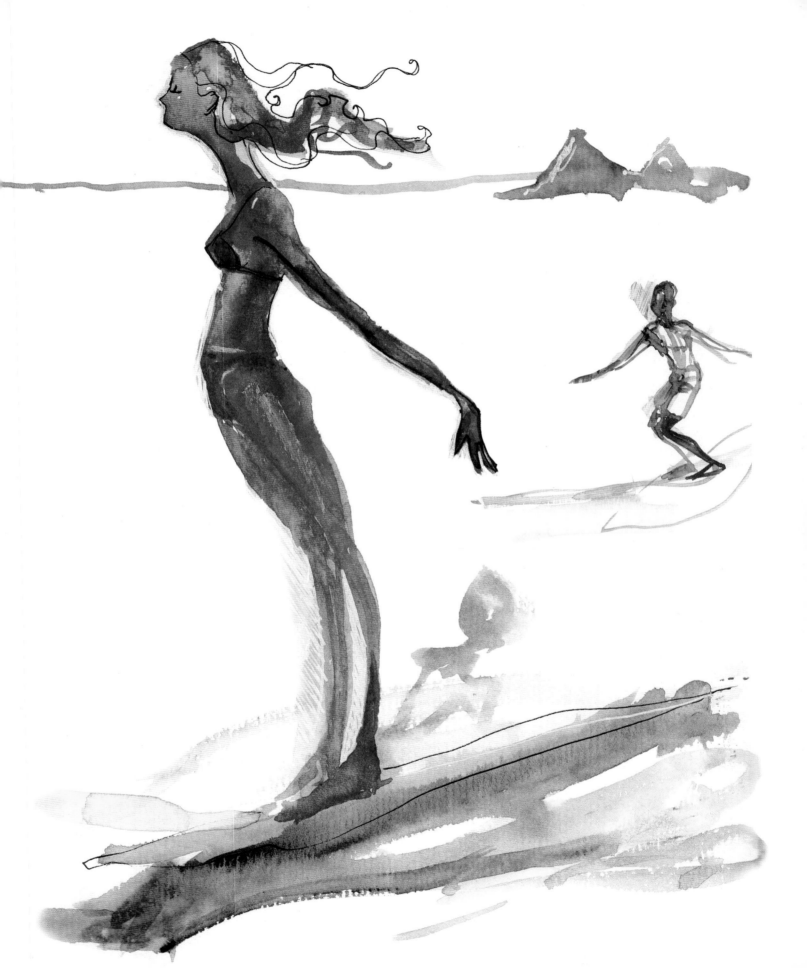

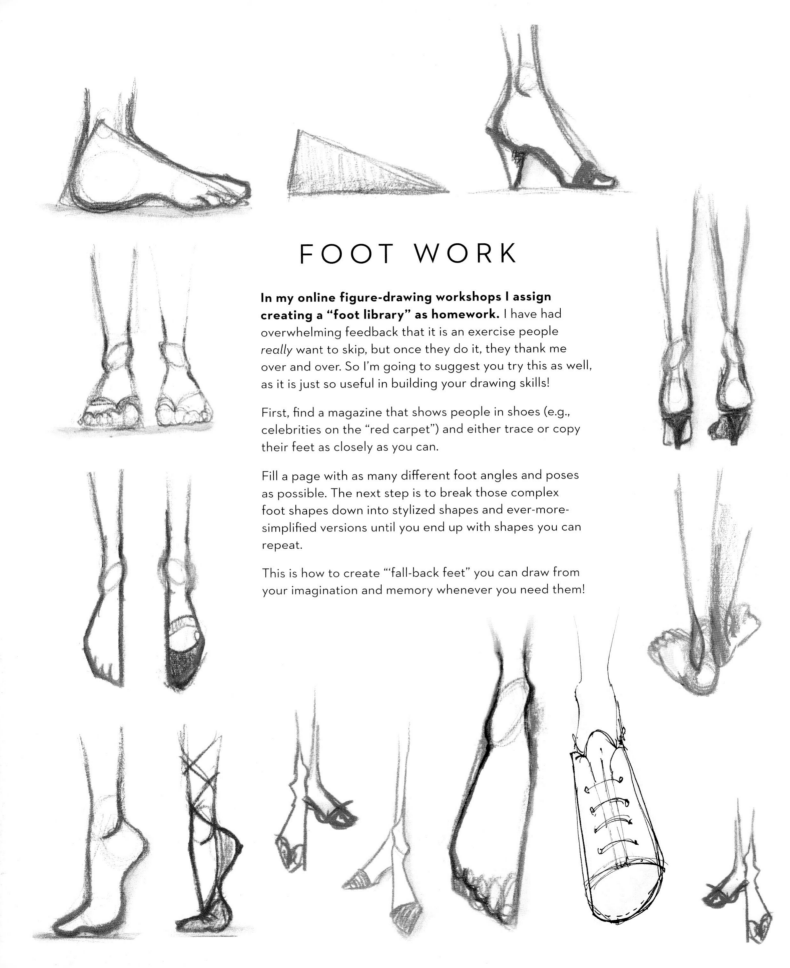

FOOT WORK

In my online figure-drawing workshops I assign creating a "foot library" as homework. I have had overwhelming feedback that it is an exercise people *really* want to skip, but once they do it, they thank me over and over. So I'm going to suggest you try this as well, as it is just so useful in building your drawing skills!

First, find a magazine that shows people in shoes (e.g., celebrities on the "red carpet") and either trace or copy their feet as closely as you can.

Fill a page with as many different foot angles and poses as possible. The next step is to break those complex foot shapes down into stylized shapes and ever-more-simplified versions until you end up with shapes you can repeat.

This is how to create "'fall-back feet" you can draw from your imagination and memory whenever you need them!

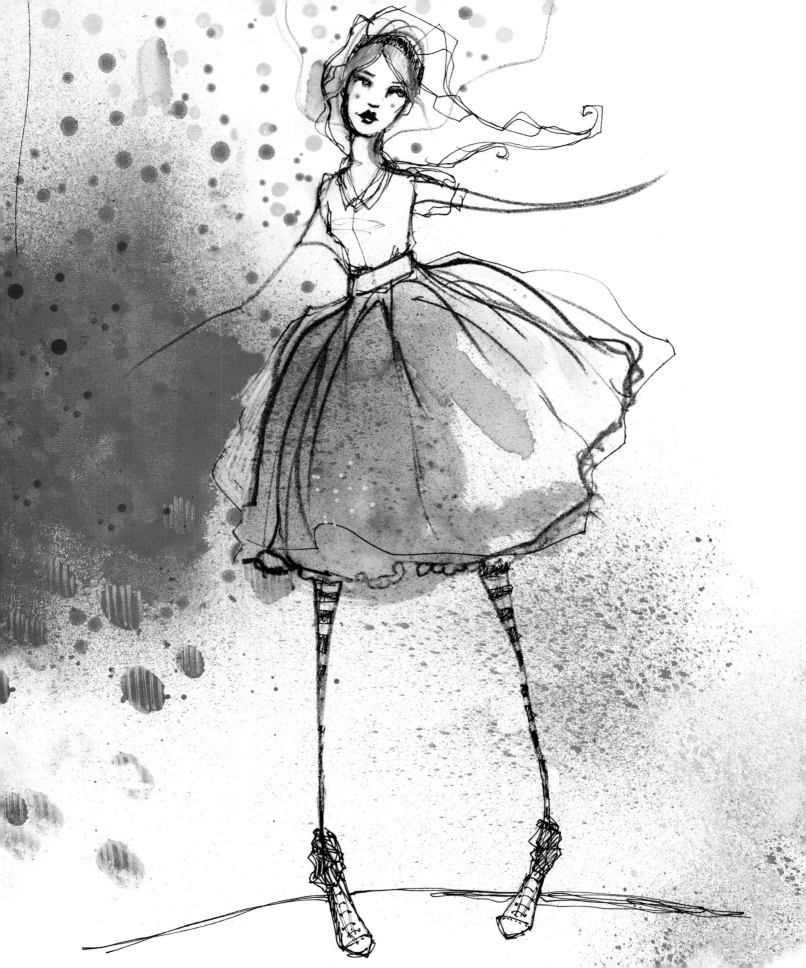

LEGGING IT

Drawing legs from the side is a rhythmic experience. Curves are followed by straighter lines and then flow into curves again.

I find this ebb and flow of opposites makes them not only easier to draw, but quite fun! Of course, you can add more curve to denote more muscle or weight, but the basic form stays the same.

Just as with arms, the joints are what will help keep your proportions in balance. The knee joint sits halfway between the hip joint and the ankle joint. Our bodies usually narrow at the joint, as there is less padding to get in the way of movement.

Practice this flow of lines to confidently create lovely legs of any size.

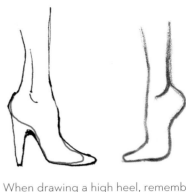

When drawing a high heel, remember that the weight isn't all on the ball of the foot as with "tippy toes." The foot can rest back on the heel of the shoe.

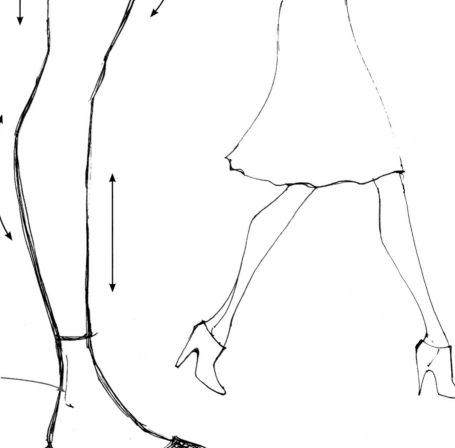

FOOTNOTE
The ankle forms a nice accent between the leg and foot. You can simply indicate it with a hooked line. Place it just above the swell of the heel and closer to the back of the foot.

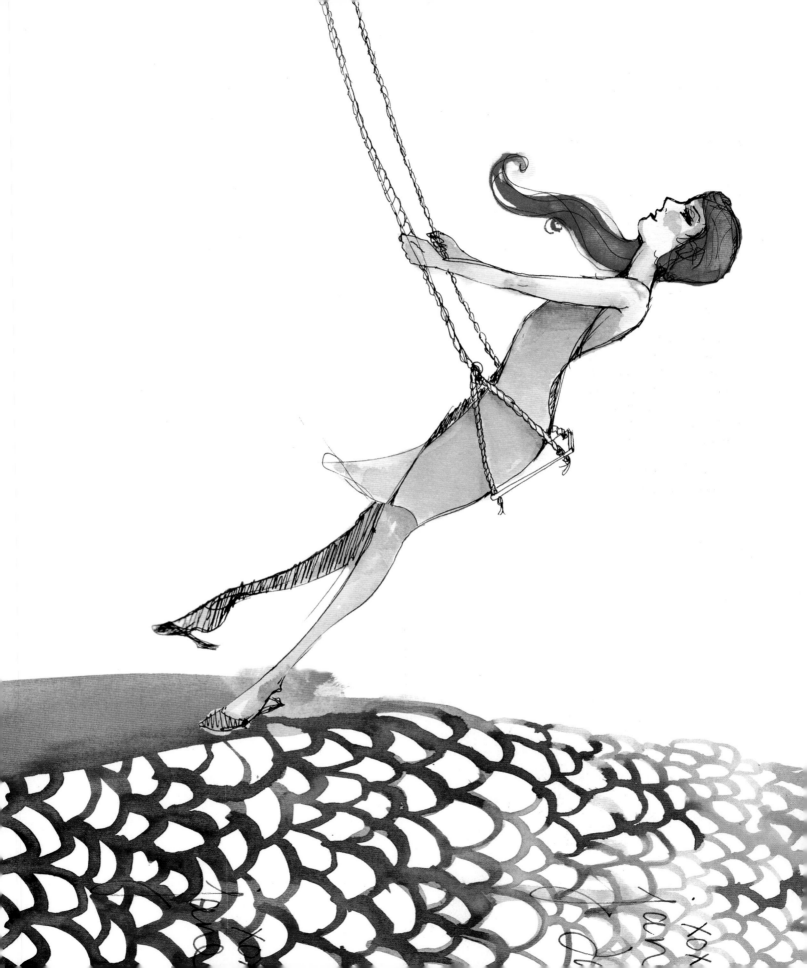

LEGS
& EGGS

These legs are rather slim, or "fashionized," so you can see the curves as clearly as possible. The muscles of the legs are asymmetrical. In other words, the muscles don't bulge evenly on both sides. I like to emphasize the difference, as it adds a little realism.

Nothing will replace your own observations of the muscles, but here are my crib notes!

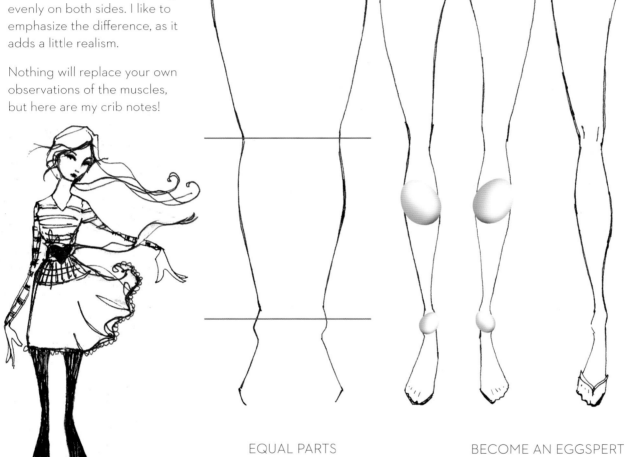

EQUAL PARTS
When drawing the legs from the front, simply remember that the joints divide the leg fairly equally, and the body narrows at a joint. I usually start the legs from the outside line, and then draw the inner line next.

BECOME AN EGGSPERT
Imagine the legs having eggs inside them at the calf and ankle. The eggs tip outward at the calf and inward at the ankle. Then draw the lines to accommodate the eggs. Eggs are also slightly more pointed at the top, and that means the muscle you draw can be a little sharper in angle at that end. The same with the ankle. The inner ankle bone is a little sharper than the outer.

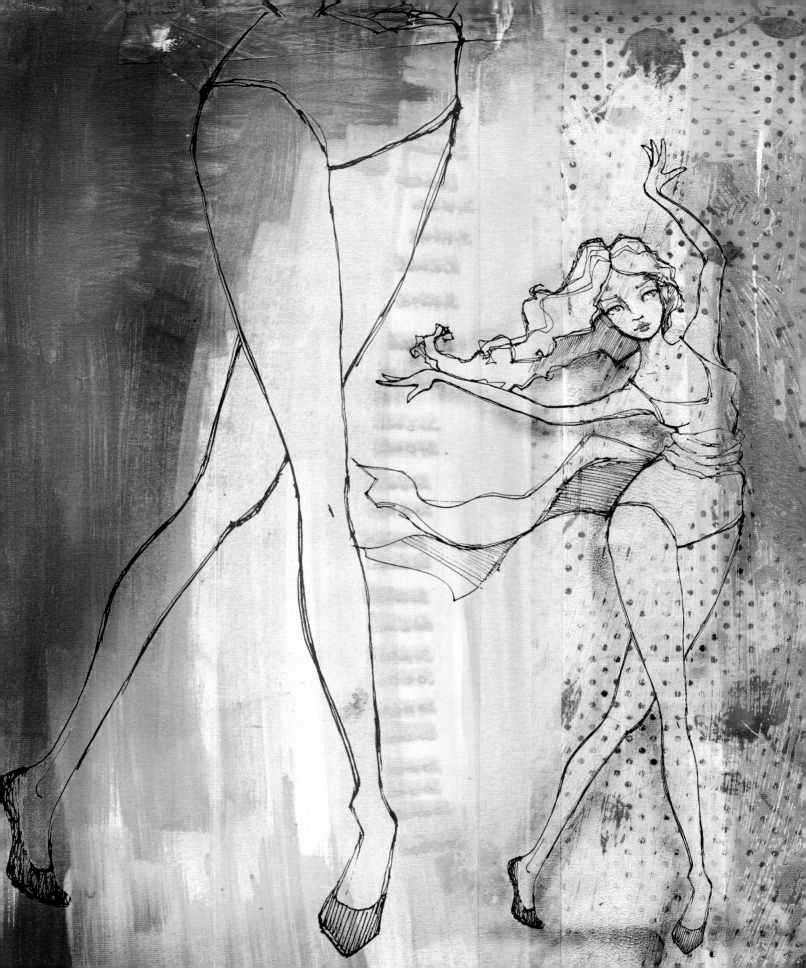

STRUT YOUR STUFF

I have already expressed my love for fashion illustration, and one of the most interesting ways to draw clothing is to draw a runway model heading toward you at full sashay speed!

In Chapter Four I showed you a very basic way to create the illusion of legs walking. Now you can add all you have learned since then!

When drawing movement, remember your Heart Lines, and which parts of the body move with each other.

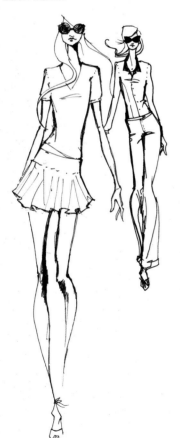

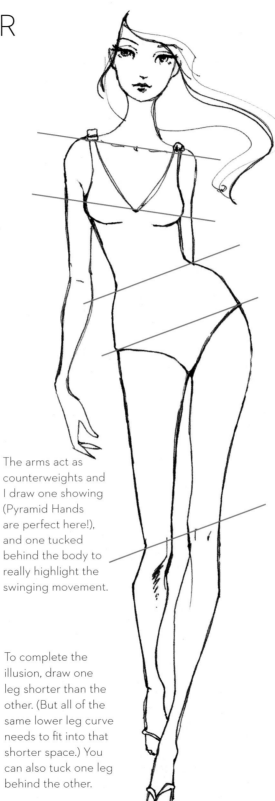

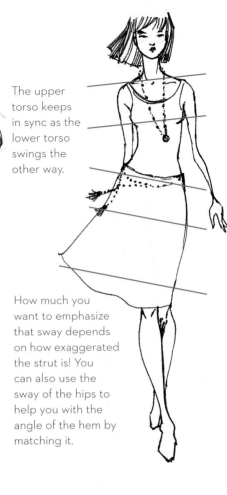

The upper torso keeps in sync as the lower torso swings the other way.

How much you want to emphasize that sway depends on how exaggerated the strut is! You can also use the sway of the hips to help you with the angle of the hem by matching it.

The arms act as counterweights and I draw one showing (Pyramid Hands are perfect here!), and one tucked behind the body to really highlight the swinging movement.

To complete the illusion, draw one leg shorter than the other. (But all of the same lower leg curve needs to fit into that shorter space.) You can also tuck one leg behind the other.

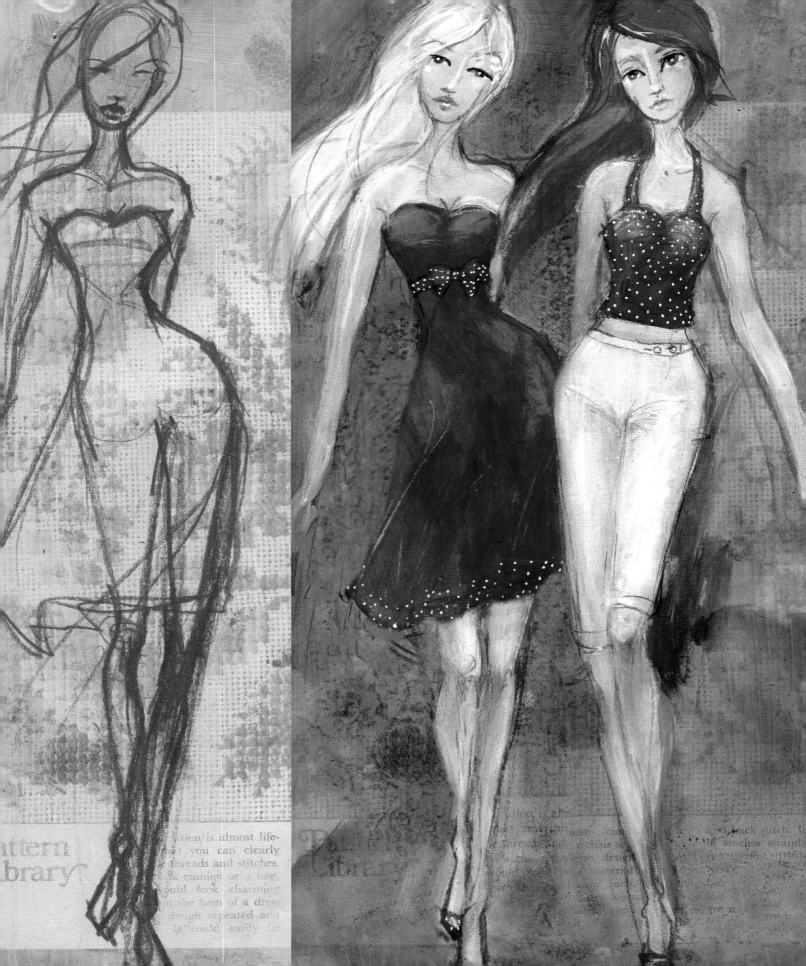

attern
brary

tion is almost life-
t you can clearly
threads and stitches.
cushion or a bag,
ould look charming
n the hem of a dress
design repeated and
could easily be

Library

BACK STORY

Every single body is different,
but there are some features that are universal enough to assist us in creating proportional figures.

The curvature of the spine is a nice line to add to the drawing of a back to give the body some definition, especially when the figure is twisted. To indicate the sway of the back, curve your spine line to roughly follow the outer lines of the body.

I usually leave the shoulder blades out of the drawing and add them with shading (which I share in a later chapter), but you can lightly indicate them.

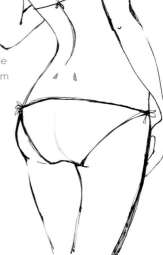

You can also add the little back dimples that indicate the triangular sacrum bone at the base of the spine.

I like to line up the top of the arm (armpit) and spine to give a neat look.

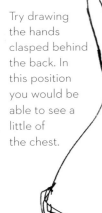

Try drawing the hands clasped behind the back. In this position you would be able to see a little of the chest.

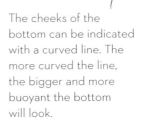

The cheeks of the bottom can be indicated with a curved line. The more curved the line, the bigger and more buoyant the bottom will look.

The back of the elbow can be indicated with a simple curve.

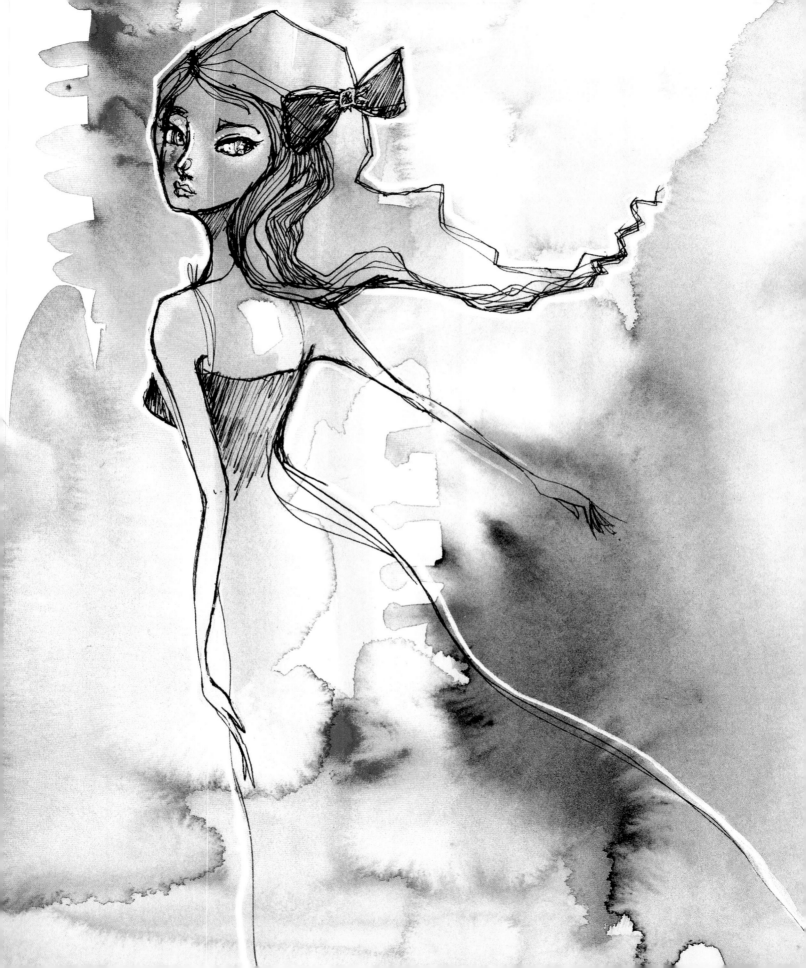

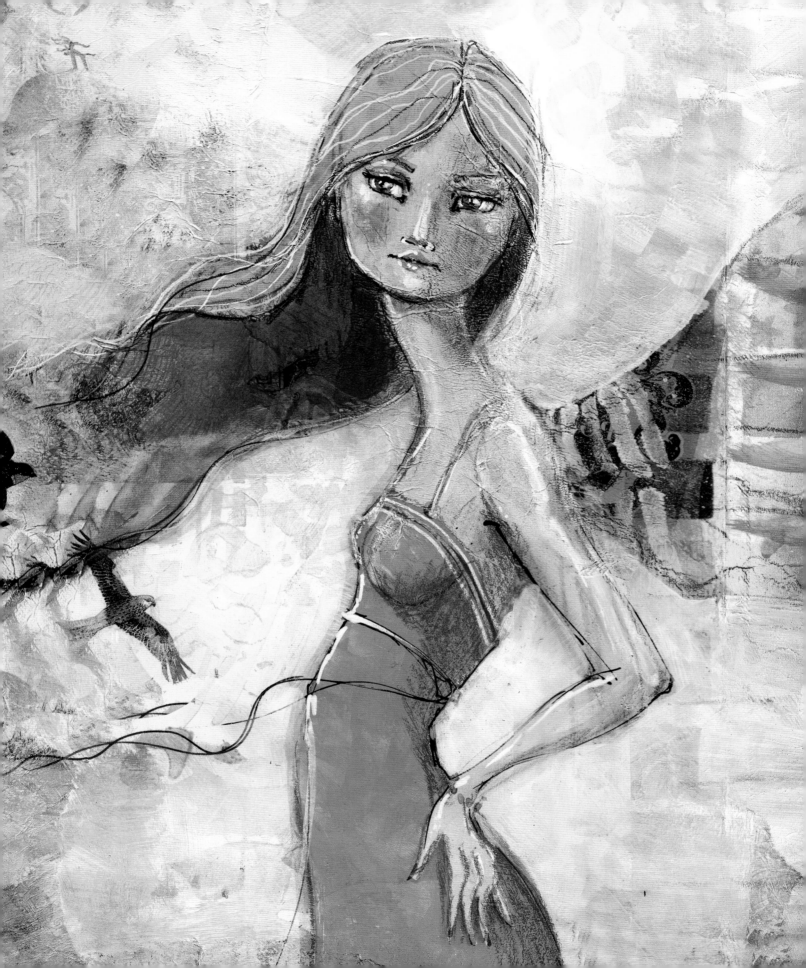

CHAPTER NINE

DRESS *rehearsal*

Our clothes say a lot about us, and the way you dress your drawings tells a story, too. Just as with hair, you don't have to keep your clothing locked in reality. I LOVE to dress my figures in things I would never wear. In this chapter I walk you through some clothing choices to try.

DRESS FOR SUCCESS

I have touched on drawing dresses and skirts in this book several times. I love the way they look when I draw them and the creative opportunities they provide.

A more fitted dress reveals the figure shape beautifully. All you need to do is add a neckline and hem. A fuller dress can add movement to your drawing; just remember to have it flowing in the same direction as the hair.

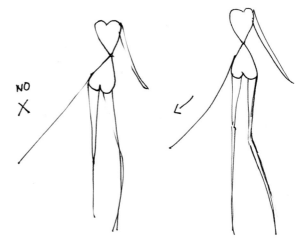

To start with, I usually take my cue from the direction the hips are swaying and add a slightly curved line, extending from the hip. If the line is not flowing or curved, the skirt will look very stiff, as if made from heavy felt.

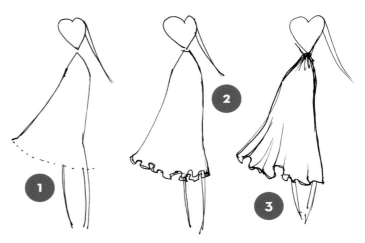

1. When you draw the hemline floating up to one side, the hem should be curved. Make sure the sides are about the same length.

2. The side of the dress that is not floating up should follow the line of the leg, as if the breeze is blowing and revealing the figure shape. The more closely you follow the line of the body, the finer the fabric will appear.

3. The more scallops, or curves, you add to the hem, the more fabric you're suggesting is in the skirt. If it's very full, you could add some gathers at the waist as well.

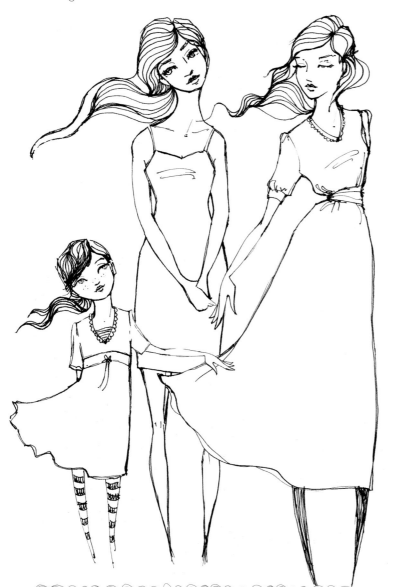

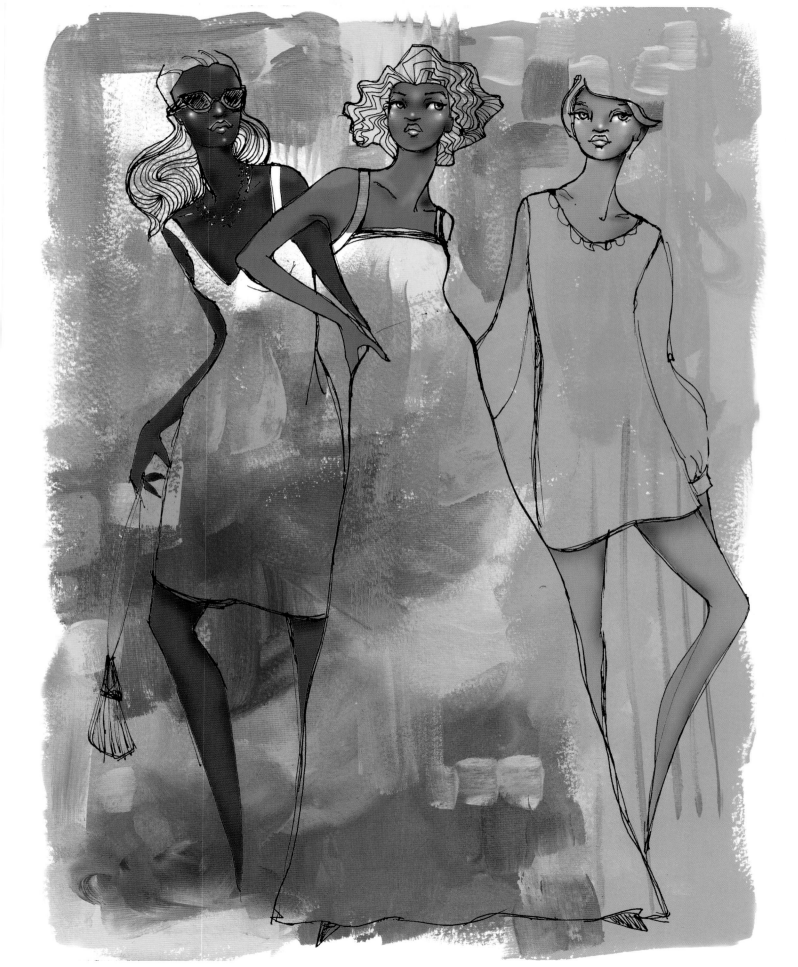

COLLARS & BOWS

I consider collars and bows accessories for my drawings. I love adding bows because they lend a girly, innocent touch and I like to draw the ends flowing in the breeze. Collars provide a frame for the neck and some nice detail. The style of collar can help set the mood as well.

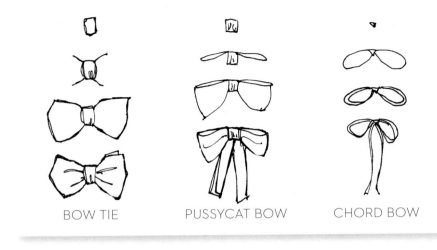

BOW TIE PUSSYCAT BOW CHORD BOW

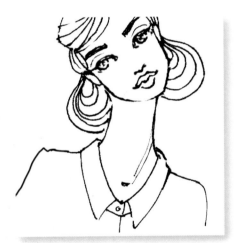

A shirt-style collar has a stand (an upright band of fabric), which gives it structure. It has a neat and elegant air to it.

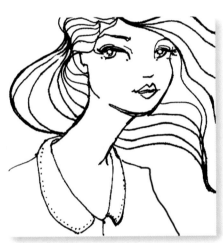

A round, or Peter Pan, collar has no stand. It lies quite flat. It frames the décolletage and is distinctly feminine.

A standing, or nehru, collar creates an exotic and sophisticated touch.

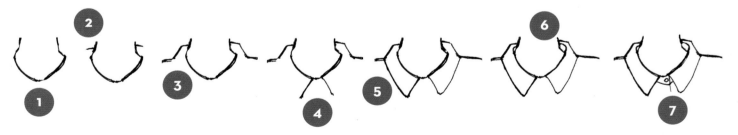

TO DRAW A SHIRT-STYLE COLLAR:

1. Make a shallow V-neck.
2. Add short lines to indicate the top of the collar as it curves behind the neck.
3. Connect the collar back to the shoulder line.
4. Add the collar wings. They sit on a slight outward angle.
5. Connect the shoulder line to the tips of the collar.

6. This is a subtle touch, but you can add a small line extending up from that original V-neck and toward the back of the collar. This forms the look of the fabric rolling over and is a nice touch of realism.
7. To finish, add the stand and a button to close the collar.

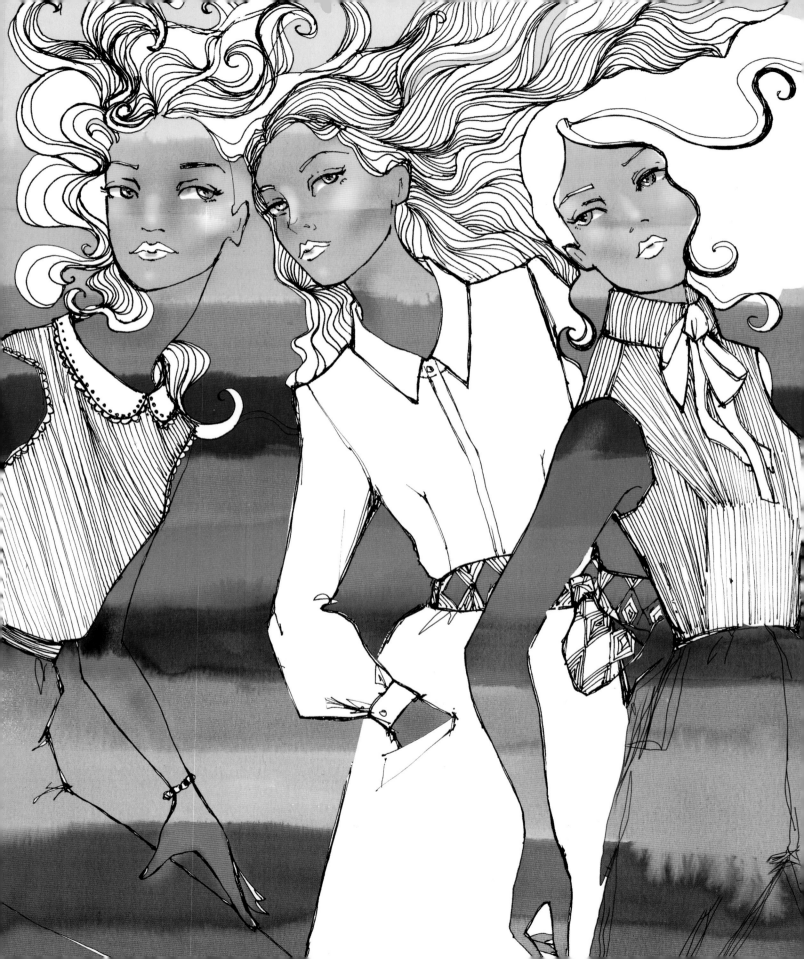

HIGHS & LOWS

The cleavage gets a lot of attention
but it really is just another part of the
body. It comes in an incredible variety
of shapes and sizes, all of which are
lovely and worthy of inclusion in our
drawings.

Here are just a few examples for
drawing the chest. I have drawn the
examples in swimsuits to more easily
illustrate details.

1. If the chest is "flat" or pre-pubescent,
then the bikini lines would be very
straight. To draw a neat or small bosom,
all you need to do is bend the bikini lines
outward slightly to indicate some shape.

2. Technically the "bustline" is fabric that
covers the breast area. To indicate that
the fabric is under tension, you can add
a squiggled horizontal line across the
breasts.

3. To draw a larger or uplifted bosom,
add a little *Y* shape in between. Breasts
are not naturally squeezed together on
their own; they need a garment such as
this "balconette" style to force the issue
a little.

4. For a more relaxed look, you can add
the inner curve of each breast to form
the cleavage. If the arm lifts, the chest
wall shifts with it, and so too does the
breast.

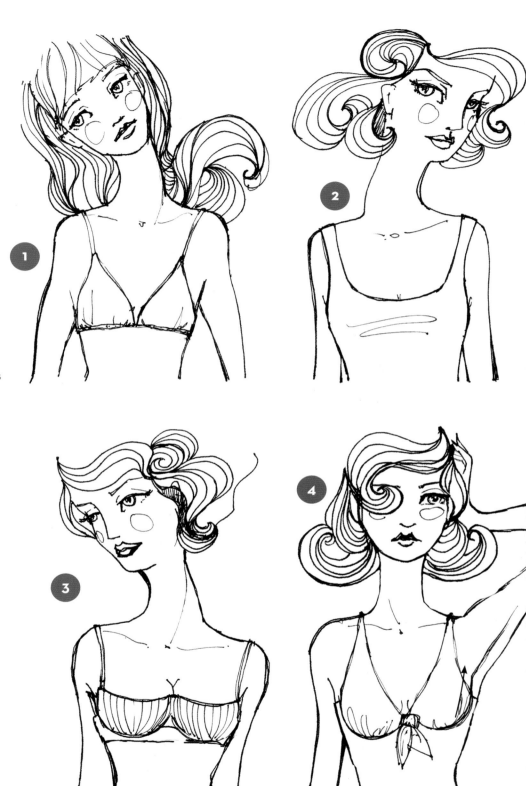

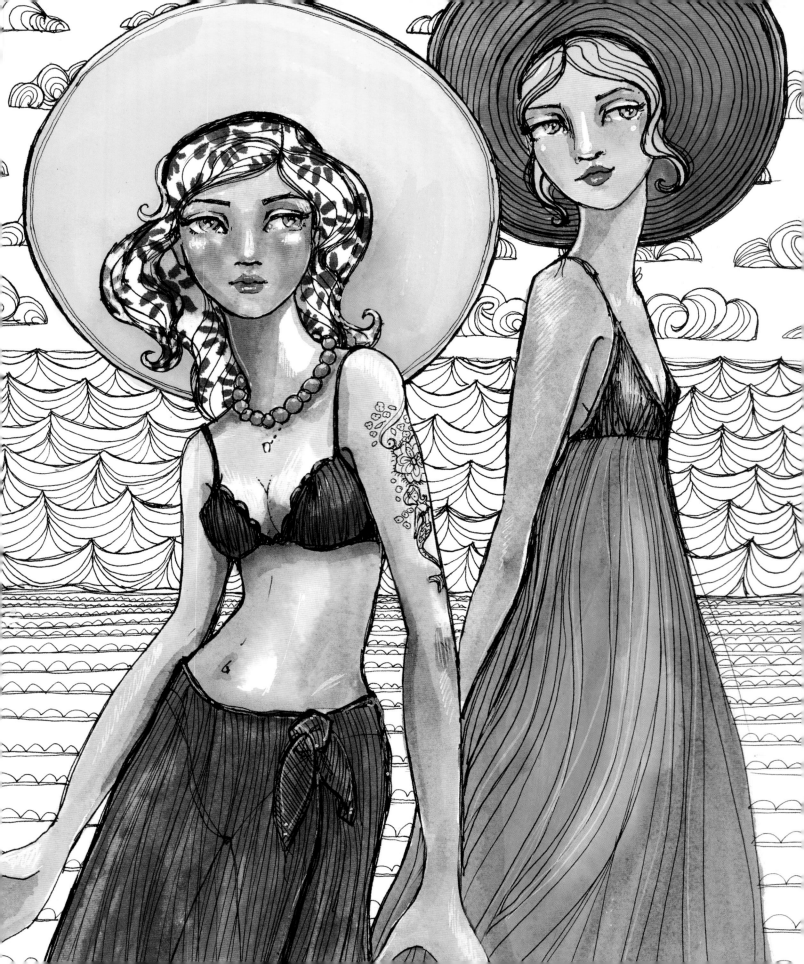

WEAR THE PANTS

Because the styles change quite dramatically with seasonal fashion, trousers may date a drawing more quickly than anything else. But they do give a drawing a dynamic edge because they allow us to see the legs in action.

These are my tips on a few styles (shown from left to right).

LEGGINGS
The easiest pant to wear is the easiest to draw, too! Just add a center seam from waist to crotch and curved lines to mark where they finish on the leg.

MEN'S-STYLE TROUSER
Fashion changes all the time, but this style is usually present in some form. Start by setting the waistline and add a few vertical lines to denote some pleats. Loosely follow the lines of the leg, but not too closely.

BOOT LEG IN STRETCH
Draw a legging to the knee, then, rather than narrowing the pant at the ankle, flare it out instead. If this were in a nonstretch fabric, you would need to add some pleats or darts at the waist and some fabric movement at the knee.

CARGO
This casual style is usually in a stiffer type of fabric, so draw the fabric standing away from the body. Add some creases in the center of each leg and angled cuffs to show dimension.

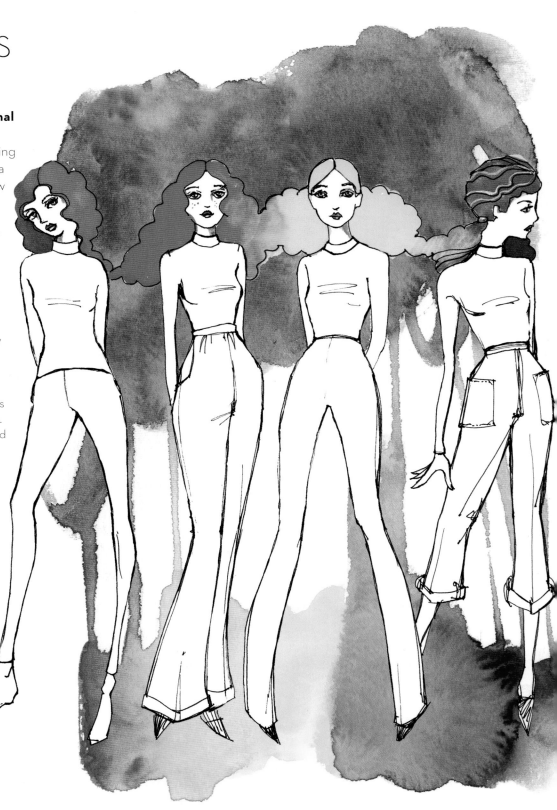

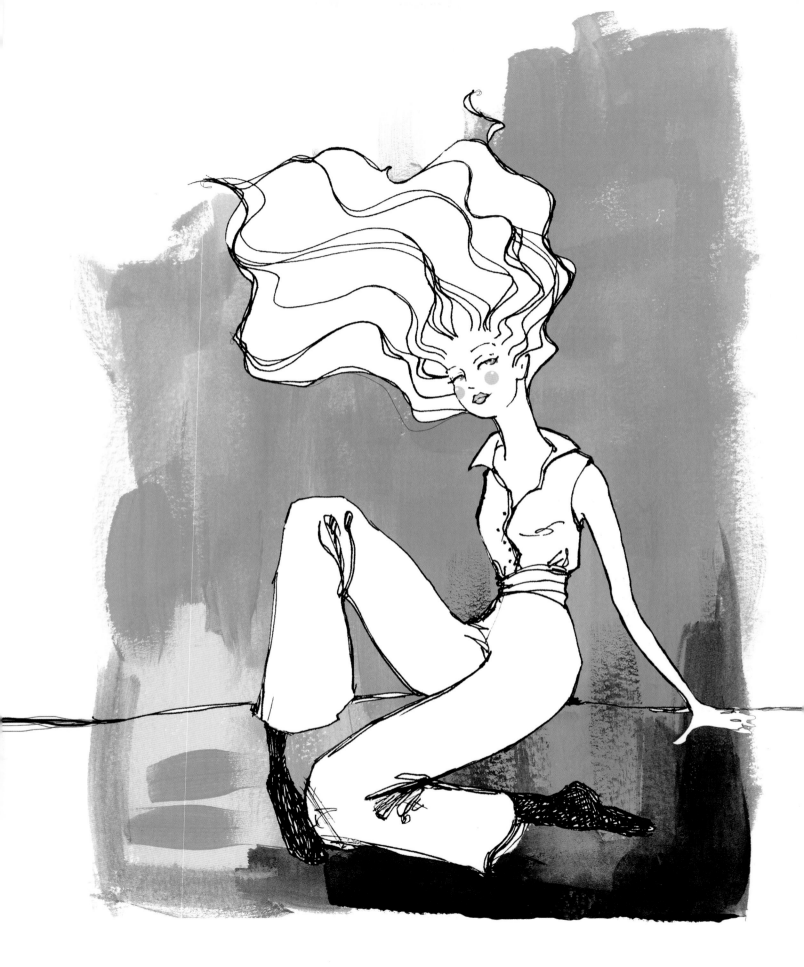

EARN YOUR STRIPES

I love dressing my drawings in stripes!
For a start, it's a fun challenge as it requires concentration and is a great way to get my head into the "creative zone." The other reason is that stripes add instant volume!

Try this for yourself:

1. Draw a shape on paper.

2. Rule parallel lines on either side of the object.

3. Connect the parallel lines and bend the lines as they travel through the object

4. Play with thicker stripes and the amount of curve in the lines to really emphasize the volume!

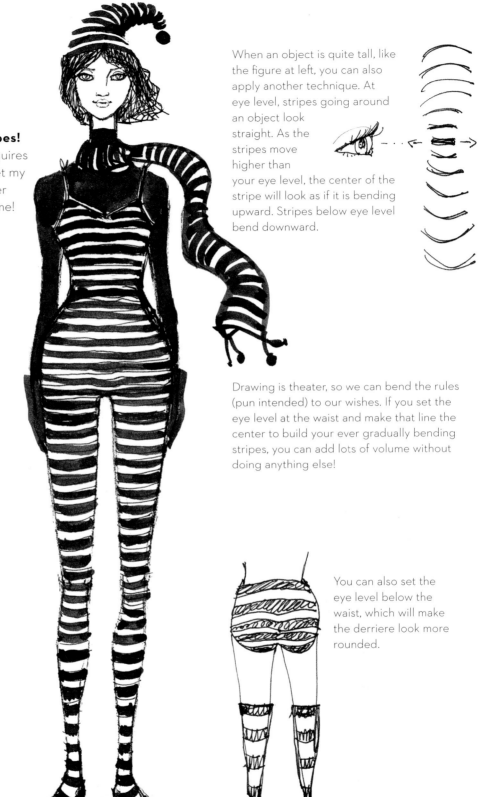

When an object is quite tall, like the figure at left, you can also apply another technique. At eye level, stripes going around an object look straight. As the stripes move higher than your eye level, the center of the stripe will look as if it is bending upward. Stripes below eye level bend downward.

Drawing is theater, so we can bend the rules (pun intended) to our wishes. If you set the eye level at the waist and make that line the center to build your ever gradually bending stripes, you can add lots of volume without doing anything else!

You can also set the eye level below the waist, which will make the derriere look more rounded.

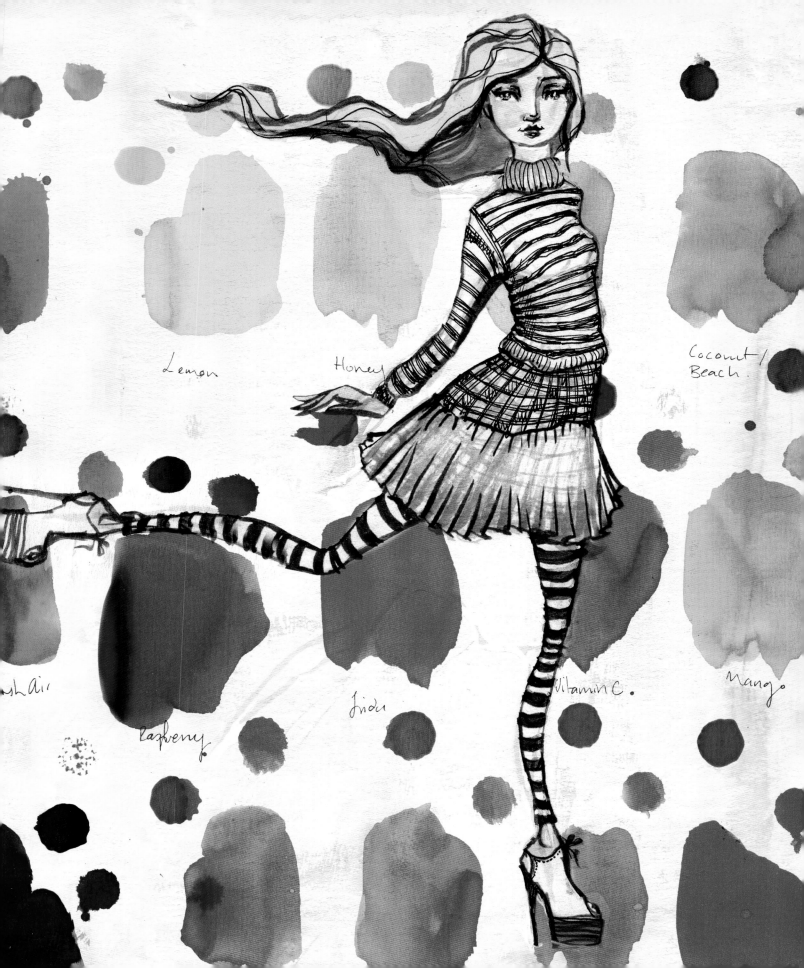

Lemon

Honey

Coconut / Beach.

Raspberry

Vitamin C.

Mango

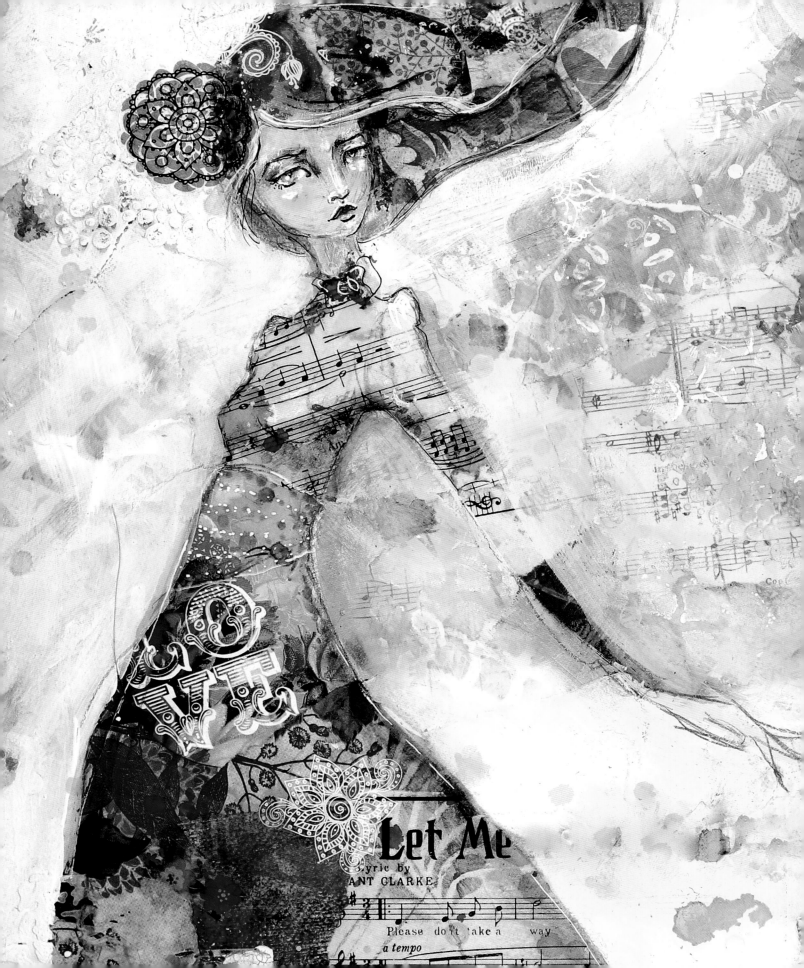

CHAPTER TEN

MADE IN
the shade

**Drawing with color allows us to add volume
and excitement.** In this chapter I will breeze
through some ideas for shading the body
and the tools that are easiest to use when
learning shading. I'll finish with some step-by-
steps of creating a finished piece.

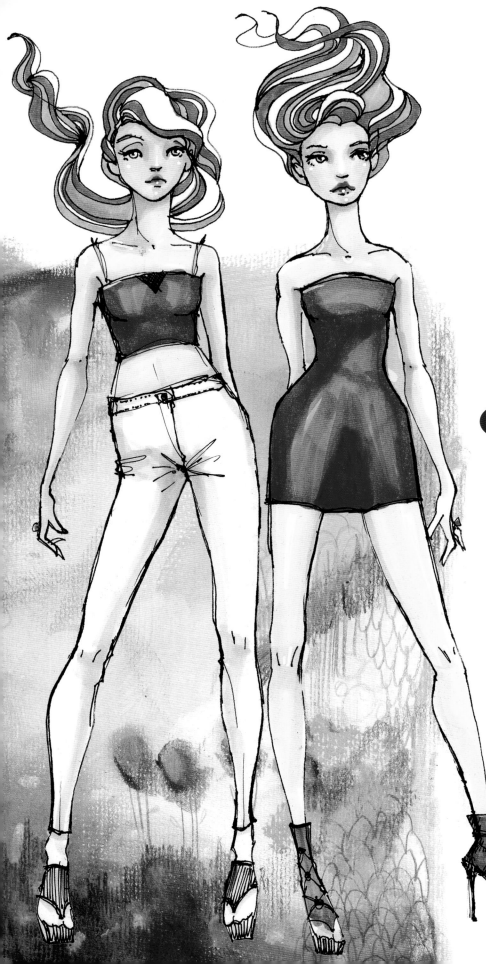

PUMP UP THE VOLUME

Time to celebrate with a drop of alcohol. Alcohol markers, that is! Alcohol markers come in a wide variety of brands (Copic, Mepxy, Prismacolor, Chartpak, and Jane Davenport, to name a few) and blend very smoothly between colors when used on specialized marker paper or blending card.

They are a wonderful way to learn shading because they are such a fast and easy medium to use. Let me walk you through one way of using them with just six colors: dark, medium and light flesh tones, a darker pink, a light pink, and a light lavender, and a white paint pen.

● ● ● ● ● ● ○

Before we start shading, we need to set the light source. Let's imagine the sun is shining gently down on our figures from the right.

In real life, we usually have light bouncing around from a variety of sources, but in drawing, we can simplify the universe and restrict it to one.

Keep in mind as you color that your first attempts may look a little streaky, but that is to be expected, so don't give up. Like all things, alcohol markers have a learning curve. The main thing is to use them on alcohol marker-friendly paper so that they can blend properly.

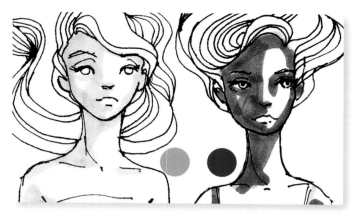

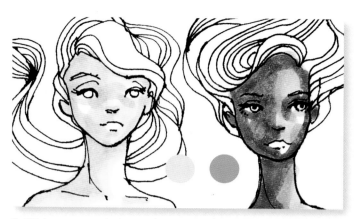

1. On the side closest to the light source (the right side in our example), shade with the darkest skin tone, leaving the paper bare for areas that would collect light on them, such as the cheekbones, the chin, and the nose. On the shaded side of the face, add marker to all the shadowed areas, especially under the chin and down the neck. Don't color into the eyes or lips.

2. With your next lightest skin tone, color over the marker you just laid down and also fill in some of the blank spaces. Coloring over the darker marker helps blend the two colors. You can leave highlights on the nose and cheekbones. Don't color into the eyes or lips.

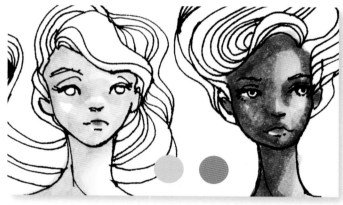

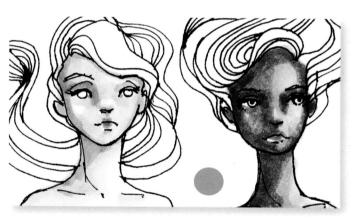

3. With the softer pink, add some blush to the cheeks, the tip of the nose, and the lips. For darker skin tones you can add your darker pink to the cheeks as well. Also add a touch of darker pink to the inner corner of each eye for the tear ducts and the middle of the lips.

4. Add the lavender to the darkest shadow areas, such as eye sockets, ears, under the chin, under the hairline, under the nose, and under the lips. A light touch is all that is needed. You can use the very lightest skin tone to help blend the lavender ink into the page if needed.

5. With the white paint pen, you can add some highlights to the nose and cheekbones and add a spark of reflection in the eyes and on the lips. Finish by adding some color to the irises. You can also color the hair. Done!

SKIN IN THE GAME

I use a similar method to get quick, volumetric effects for my figures. I am using four alcohol markers and a white paint pen, but you can try the same principle with other materials. This system works with any skin tone! You just need a dark and light flesh tone, a pink to add life, and lavender to add deeper shadows.

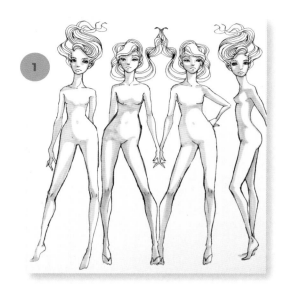

1. Start with the darker flesh tone and add this wherever shadows would appear on the body. Another way to think about this is to place color around and under any part of the body that protrudes out, such as the chest, tummy area, front of the thighs, and arms.

2. Color over all of the first flesh tone with the lighter flesh tone and add a little more. This gives the effect of a softer transition from light to dark.

3. Add touches of soft pink to joints, lips, and cheeks. This gives life to the figure.

4. Use lavender to add extra depth to the darkest shadows, such as under the chin, under the bust, the inner thighs, under the knees, and under the arms. Here I also added lines to denote clothes.

5. Use a white paint pen to add in any highlights, such as on cheekbones, clothes, shoulders, hip bones, and shin bones.

It doesn't matter which colors you use. The trick is to select your two skin tones well. Don't make them too similar, or too dissimilar.

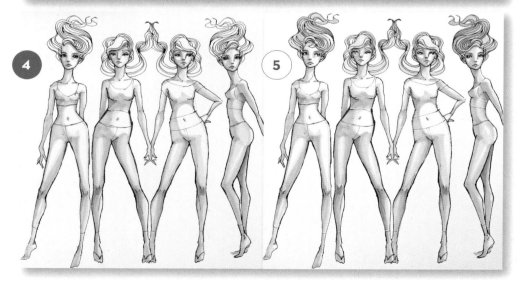

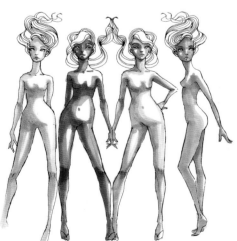

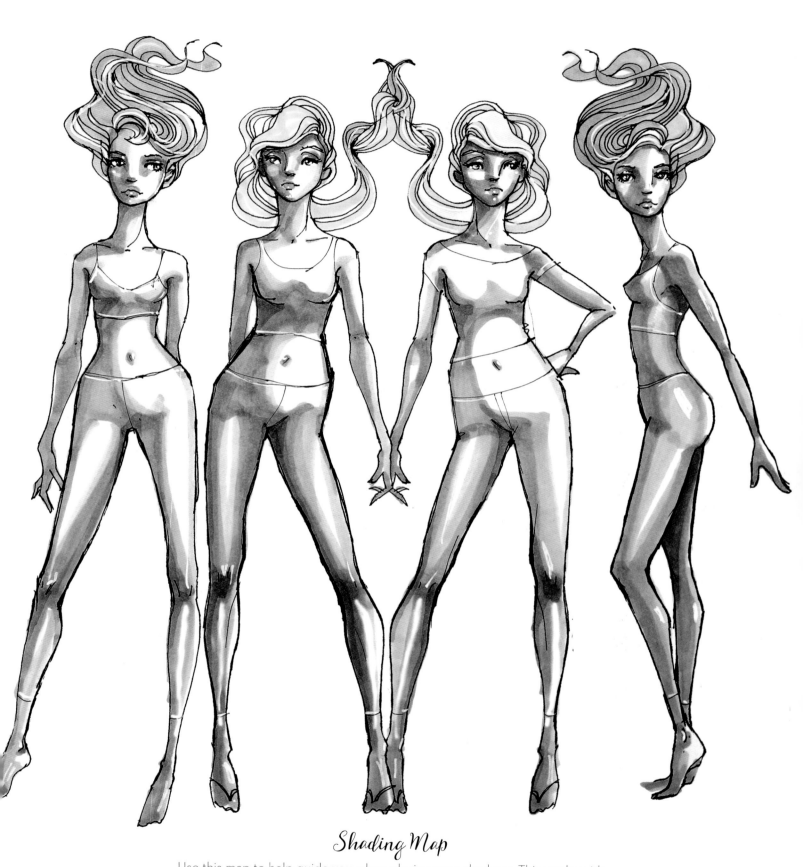

Shading Map

Use this map to help guide you when placing your shadows. This works with
any skin tone. I've shown it in gray so you can see the shadows clearly.

SITTING PRETTY

Let's shade the back and talk about drawing a seated figure.

When we stand, the bottom cheeks are quite rounded.

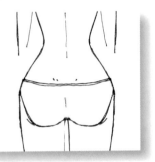

When we sit, the bottom flattens and spreads out a little. Also notice the way the bikini bottom is drawn in the images on the right. As we sit, the curve of the waistline becomes deeper.

I shade the back by starting at the waist. This helps with the illusion that the back comes in at the waist. Then I add some shading up the spine and in the little dimples that indicate the sacrum bone at the bottom of the spine.

Then I shade the arms and sides of the body, coming under the shoulder blades. I personally tend not to draw shoulder blades, but instead indicate they are there with the shading.

The last part is to shade the bottom of the bottom. I leave some white highlights for the roundest part of the bottom cheek to indicate volume.

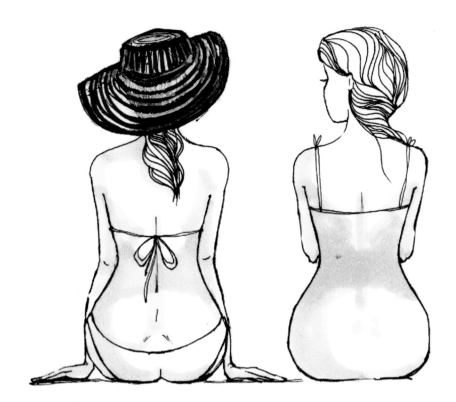

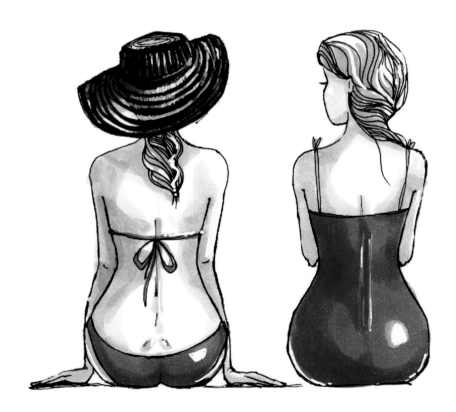

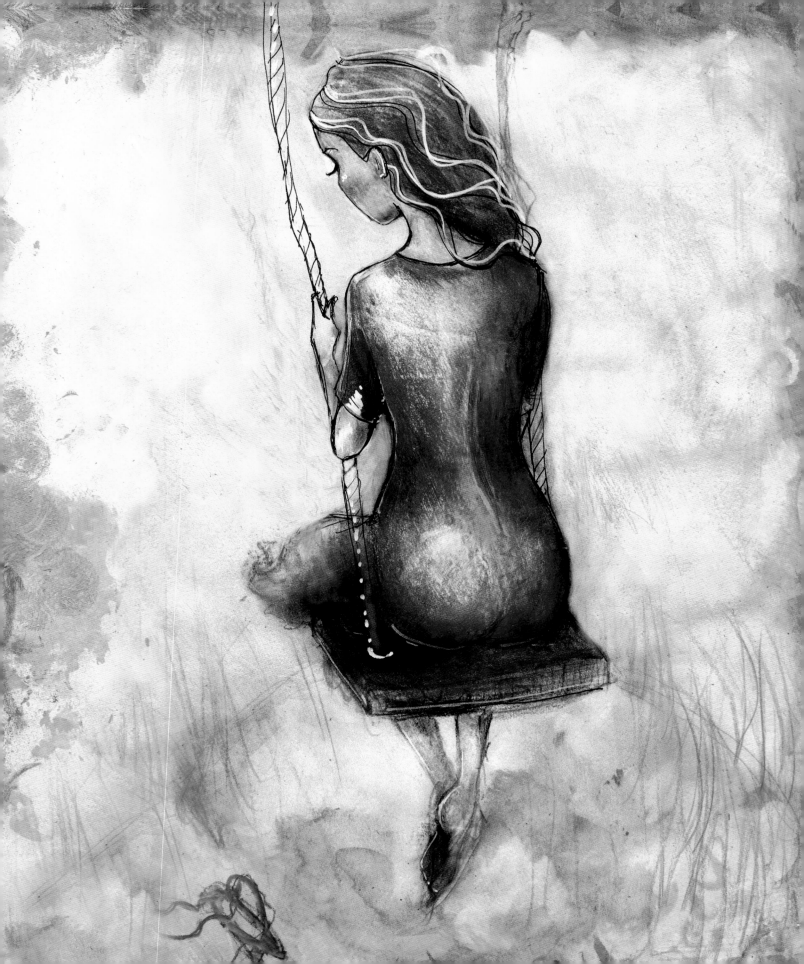

BONE TO PICK

The focus of this lesson is the collarbone area. The clavicles are the two longest horizontal bones in our bodies and are separated by the jugular notch. Together they have a lovely form that catches the light and adds a nice touch of nuanced realism to your drawings. A little bit of shading goes a long way here.

1. Start by sketching with several different colored pencils. This gives the drawing a lively energy.

2. Build up the facial features with watercolor pencils and create the shading by adding water to blend.

3. To define the jugular notch, lightly extend a line from the side of the neck to the center and below the shoulder.

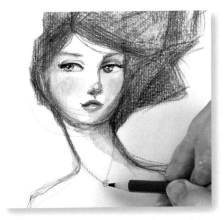

4. Repeat on the other side, but with even less pressure. When finished, these lines will look like neck muscles.

5. To form the first clavicle, draw a line coming from the shoulder cap to the jugular notch.

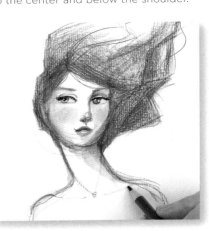

6. Repeat to define the second clavicle. Keep your lines light. These are subtle touches that you can add shading to.

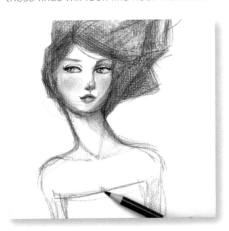

7. The focus is the head, shoulders, and décolletage, so I added a line to indicate a simple shift dress.

8. I added color with rub-on transfers from my own collection and a background of painted swatches.

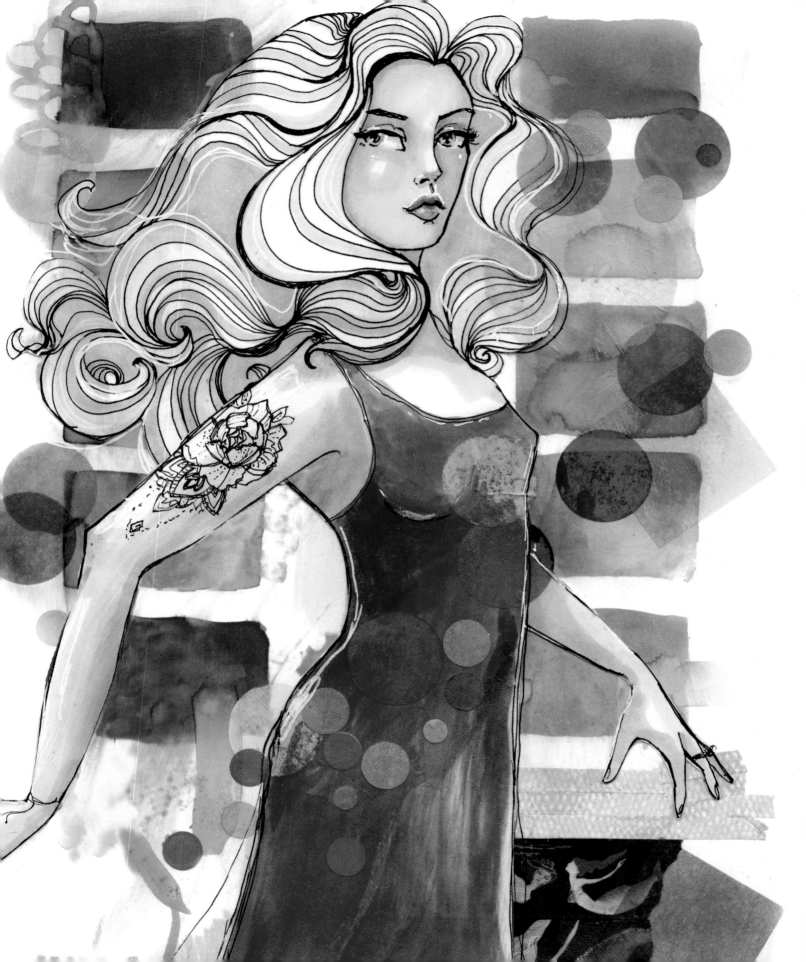

THANK
you

A personal message for you

It's such a pleasure to walk with you for a bit on your creative path. The joy, freedom, and exhilaration you feel when you move your pencils and brushes is priceless.

There is no right or wrong on this artistic journey. It is going to take time to develop your own skills and your own style, so you may as well give in to it and enjoy the journey.

My motto is "Trust the Mess." It means not just accepting mistakes and missteps, but welcoming them. They are part of the creative process and you cannot develop as an artist without taking a risk. It's only paper, after all!

Until we meet in a workshop or in my next book, keep on creating and paint 'til you faint!

xoxox,

jane

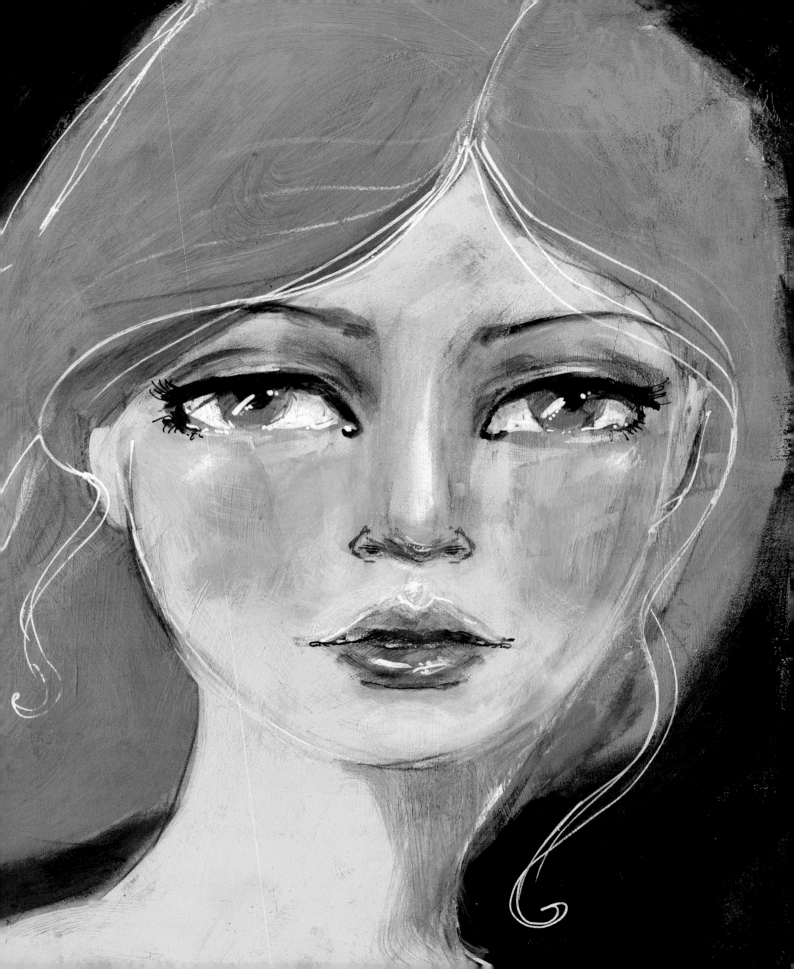

ABOUT THE AUTHOR

Jane Davenport's passion is teaching women how to defy self-imposed creative gravity. She is a professional artist, best-selling author, workshop leader, and art director of her own line of art supply products. In her spare time, Jane is an avid art supply junkie, art journal evangelist, and koala mama (yes, koalas visit her garden!).

After studies in Paris, Jane began her career as a fashion illustrator. She went on to become a textile designer and fashion designer, collaborating with her mother, fashion icon Liz Davenport. Jane soon discovered another love—photography. She went from designing fashion to shooting it as a runway photographer. A fascination with ladybugs became an obsession with photographing insects. Her insect-inspired photos have been exhibited throughout the world, and Jane has published four books on bugs. In 2007, Jane and her husband, Gus, opened a gallery, The Institute of Cute, in Byron Bay, Australia, which showcased her artwork and licensed collections of housewares, clothing, textiles, and stationery. Teaching a weekly drawing and painting class at the gallery led Jane to discover a true passion for sharing and teaching. She turned her focus to teaching online and now has thousands of students who sign up for her online workhops.

Jane and Gus live at "The Nest," overlooking Byron Bay, Australia, with their three small dogs, Moo, Tinsel, and Gesso. See more at www. janedavenport.com.

INDEX

YOUR *invitation!*

I ♥ DRAWING

fabulous
FIGURES
THE *e* COURSE

Would you enjoy developing your skills and artistic confidence even further? If so, you are invited to join the online workshop that Jane Davenport has specifically designed to expand on the techniques in this book.

The beauty of online workshops is that you get to study at your own pace, at your own convenience, and you can review the materials as often

as you need to let each lesson sink in. Plus, you can learn in your pajamas! You can join Jane Davenport's creative community to share your homework and get answers to your questions on drawing and art supplies.

This book is an important part of the workshop, and you will need a copy to participate.

For full details, go to Jane's website:

WWW.JANEDAVENPORT.COM